W9-DBS-873

The Campus History Series

THE UNIVERSITY OF
ST. FRANCIS

UNIVERSITY OF
ST. FRANCIS®
Respect. Service. Integrity. Compassion.

ON THE FRONT COVER: This photograph, taken during the 1937–1938 academic year, shows the campus facing west along Taylor Street. The three students are sitting on the wall that ran in front of the Motherhouse (right) and St. Joseph's Cottage. The wall and St. Joseph's Cottage now exist only in photographs and memories, while the Motherhouse remains a fixture on the USF campus. (Courtesy of the University of St. Francis Library Archives.)

ON THE BACK COVER: Completed in 1923, Tower Hall is the main entrance to the campus and the main educational building at the University of St. Francis (USF). In its early days, in addition to housing sister students and faculty, the building boarded women who were attending the College of St. Francis and female high school students from St. Francis Academy (now Joliet Catholic Academy), which was located in Tower Hall until it moved to its current location in 1956. (Courtesy of the University of St. Francis Library Archives.)

The Campus History Series

THE UNIVERSITY OF ST. FRANCIS

LINNEA KNAPP

ARCADIA
PUBLISHING

Copyright © 2010 by Linnea Knapp
ISBN 978-0-7385-8416-4

Published by Arcadia Publishing
Charleston SC, Chicago IL, Portsmouth NH, San Francisco CA

Printed in the United States of America

Library of Congress Catalog Card Number: 2010920265

For all general information contact Arcadia Publishing at:
Telephone 843-853-2070
Fax 843-853-0044
E-mail sales@arcadiapublishing.com
For customer service and orders:
Toll-Free 1-888-313-2665

Visit us on the Internet at www.arcadiapublishing.com

To the padres, who claim my love of books comes from being born next to the library. I love you for it.

CONTENTS

ACKNOWLEDGMENTS

A great amount of thanks is owed to Sister Marian Voelker, OSF, archivist of the Sisters of St. Francis of Mary Immaculate. She is the gold standard for historical knowledge about USF, and her resources and fact-checking were invaluable. I also must thank my fellow USF Librarians who helped me research those specific little details and dates that I just had to have. Thank you to my proofreaders, Sister Marian and Lisa Quinn, for getting me out of the dense USF history clouds to make the book readable for all.

Thank you to Tim Clodjeaux, USF sports information director, for gathering the great sports images and providing amazing information to go with them. Another big thank you is owed to the USF Alumni Relations Office for their partnership, which allowed us to move forward with this project. And finally, thank you to all the photographers who took the time to document USF throughout the years, especially Ron Molk for his recent work with USF.

Since arriving at USF, I have been continually amazed by the history of the school and the people and events that have helped shaped it. I am extremely grateful to all the people throughout the years who saved when they could have discarded; creating the room of treasures that is now the USF Library Archives. I praise God for the opportunity to be the archives librarian at USF and the chance to create this book. A school with this many stories is yearning to have them told; thank you for taking the time to listen.

Unless otherwise noted, all images appear courtesy of the University of St. Francis Library Archives and the archives of the Sisters of St. Francis.

INTRODUCTION

The Sisters of St. Francis of Mary Immaculate have served in Joliet since Mother Alfred Moes founded the congregation in 1865. Under direction of the Very Reverend Pamfilo da Magliano, OFM, the first postulants were admitted March 24, 1865. A short time later, in 1876, Mother Moes moved to Rochester, Minnesota, where she worked with the Mayo doctors and a father and his two sons to found St. Mary's Hospital, now a part of the famous Mayo Clinic, but the sisters remaining in Joliet continued their ministries. The sisters were busy taking in orphans, boarding students from three years old to late teens at St. Francis Academy, staffing various parish schools, and serving various ethnic groups during their adjustment to American life. Their desire to serve the people in their community led them to study and master those areas of academia that they saw as essential to providing a well-rounded education through their schools.

Word soon spread throughout the region of the quality of education provided by the sisters, which in turn created significant growth in enrollment through those early years. St. Francis Academy for high school girls was organized as a boarding and day school around 1869 and accredited as an "institution of learning" in 1874. The sisters continued to teach high school girls but saw the need for an education for their students beyond what they currently offered. Building off their current work of educating sisters and postulants to become teachers, in 1920 they formed a college department within the congregation. In 1925, the college department became a formal two-year junior college admitting students from outside the congregation; the school was called Assisi Junior College, and after the first successful year the Illinois State Board of Education accredited it. The school's name was changed in 1930 when the curriculum grew to a four-year format, and the College of St. Francis (CSF) was officially established.

The first few decades at CSF brought much growth and excitement for students, staff, and the community alike. Programs and events established then are still a part of the school's campus life today; these include a 1935 course affiliation program with the St. Joseph Hospital School of Nursing that has grown into the university's College of Nursing and the radio workshops, which began in 1945 and exist today as WCSF, the university's student-run FM radio station. In addition, during this time the school created foreign language, art, and science majors, which remain immensely popular among students.

The campus was initially comprised of only the academic wing of the Motherhouse convent and the newly constructed Tower Hall, but by the 1950s it became apparent that the college had outgrown their buildings and the sisters began to make plans to expand. In 1946–1947, the school purchased three mansions on Bridge Street to be used for temporary off-campus housing for upperclassmen, but even this did little to improve the space issues faced by the sisters and students. A new residence wing was added to Tower Hall in 1955, and with the relocation of St.

Francis Academy out of Tower Hall and into a new location on Larkin Avenue, much more space for academic and residential activities opened up in the building. Additional academic space was gained when the St. Albert Science Building became the third main building on campus in 1959. The rate of applications continued to surpass the availability of on-campus rooms, which led to the construction of Marian Hall, a large dedicated residence hall, in 1966 and a separate library building in 1968. Both these buildings were erected on land donated to the school along the south side of Taylor Street, enlarging the footprint of the main campus.

In 1962, the College of St. Francis was officially incorporated, making it an independent institution; shortly following this change, the school welcomed their first lay president in 1969. The school went through even more changes with a tentative merger with Lewis College (now Lewis University) in Romeoville, Illinois. For one year, Lewis-St. Francis of Illinois functioned as a joint school but was ultimately unsuccessful. With the dissolution of the merger, CSF remained a coeducational institution and continued to welcome male students. The presence of male students on campus brought changes to the athletic department, and the offering of intramural sports was supplemented with varsity athletic programs, which grew quickly. To accommodate this rapid expansion of programming, the Fighting Saints constructed the new recreation center in 1986, the sixth building to be erected on the CSF campus.

Throughout its continuous evolution, the school's academic offerings continued to grow. In 1972, it began to offer off-campus degree programs throughout the country, and new majors were added in 1979. In 1980, the first master's program open to students outside the congregation was created. By 1990, CSF had nearly 30 distinct majors and minors, including three preprofessional programs, and there were over 20 activities and clubs that students could be a part of, including professional clubs, sororities, and honor societies.

The school was poised to enter the last decade of the 20th century as a top Catholic liberal arts college. In 1993, CSF added one more building to the campus with the construction of the Moser Performing Arts Center. This newest building was attached to Tower Hall and dramatically increased the space available for the music and theater departments. Having completed the long-dreamt-of performing arts center, the school looked to the future and used existing space to increase technology on campus through the creation of computer labs and increased Internet access.

In 1998, the school saw another significant change when the board of trustees voted to move to university status. On January 1, the College of St. Francis officially became the University of St. Francis. The path to obtaining university status started with the Sisters of St. Francis following their mission to provide education in their community and grew to become the beloved and high-quality school it is today. As of 2010, USF boasts an online and in-person curricula of nearly 50 undergraduate majors, 13 master's programs, and its first doctoral program in nursing practice, in addition to maintaining the adult degree completion program started early in the school's history. USF has 3,340 students and 17 athletic programs on a 22-acre campus and continues to work towards its mission of striving to be "a Catholic university rooted in the liberal arts" and focused on the Franciscan ideals of respect, service, integrity, and compassion.

The histories of the Sisters of St. Francis and the University of St. Francis are deeply rooted in Joliet, and the educational programs provided by the schools in its various forms have been fixtures in the area for nearly a century. The history of the school provided in this book offers insight into the daily and scholastic lives of college students in the area, showing the progress over time in both educational and cultural environments.

One

PRELUDE TO A UNIVERSITY
1865–1920

The congregation of the Sisters of St. Francis of Mary Immaculate in Joliet, Illinois, was officially established August 2, 1865, by Fr. Pamfilo da Magliano when he placed Mother M. Alfred Moes in leadership of the first Franciscan Sisterhood in Illinois.

Two sisters had already begun teaching at St. John the Baptist School in Joliet while living in the upstairs of a small stone house still standing at 405 Broadway Street. Early in 1864, Mother Alfred purchased a house and two adjoining lots on Division Street, which, with an addition in 1871, became the first St. Francis Convent and Academy. Education was the primary concern of Mother Alfred and her sisters. Pastors from parish schools in Illinois and surrounding states requested teachers, and the sisters worked hard to meet those needs.

In May 1874, St. Francis Academy was granted a charter as a "seminary of learning for young ladies." Circumstances forced a change in leadership for the sisters, and Bishop Foley separated Mother Alfred from the Joliet congregation. Joliet businessmen secured 13.25 acres for the sisters on Plank (Plainfield) Road where the new St. Francis Convent and Academy, under new leadership, opened in August 1882. The former Motherhouse was sold to the Franciscan Sisters of the Sacred Heart to become St. Joseph Hospital.

In June 1904, the sisters made the painful decision to close the academy due to limited space and faculty; only the music and art courses were continued for the sisters and day students. With the generous support of the citizens of Joliet and academy alumnae, the sisters were able to build the south wing along Taylor Street. The 50th anniversary of the congregation was celebrated with the reopening of St. Francis Academy in the new wing in August 1915.

St. Francis Academy flourished, and within a very short time, it had once again outgrown its quarters. In 1922, the sisters built Tower Hall at the corner of Wilcox and Taylor Streets. This new building allowed the sisters to expand their educational services, further laying the groundwork for the university.

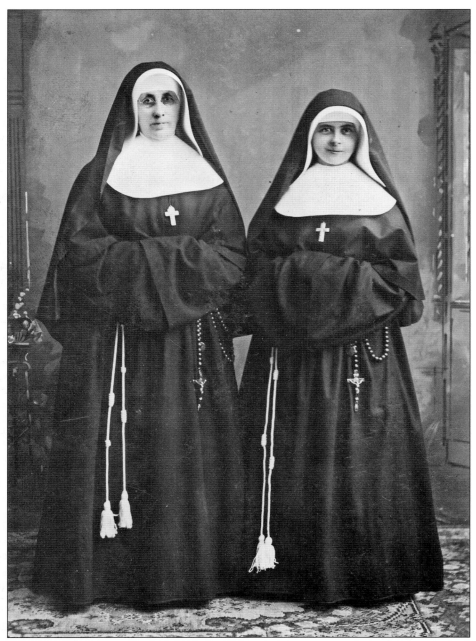

Mother Alfred Moes (left) was born Maria Catherine Moes in Luxembourg in 1828 and, with her sister Catherine, came to America in 1851 to serve God by teaching in the "Indian Missions." By the time they arrived, their focus had changed, and Mother Moes spent her years with the Franciscan order in various ministries. She founded both St. Mary's Hospital in Rochester, Minnesota, now part of the Mayo Clinic, and St. Francis Academy, in Joliet, Illinois, the school that started the network of learning and teaching institutions that eventually grew to include the University of St. Francis. She is pictured here with a companion, Sister Kostka Boesken, who served with her during her time in Rochester, Minnesota.

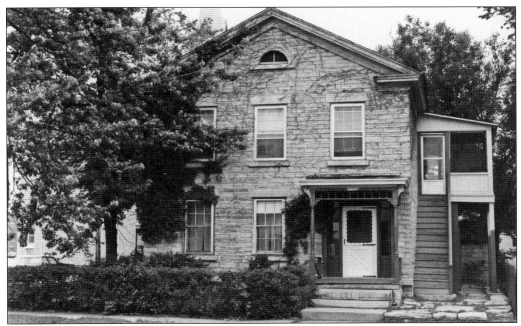

Upon her arrival in Joliet on November 4, 1863, Mother Alfred rented the top floor of this little house at 405 Broadway Street (above). She lived there until March 1864, when she purchased a small house on the other side of Broadway Street facing Division Street. This house (below, in the foreground) was the beginning of the St. Francis Convent and Academy. In 1871, a large addition was added and it became the first Motherhouse. The sisters, novices, postulants, aspirants, orphans, and boarding students all lived there together until they moved in 1882. The Franciscan Sisters of the Sacred Heart purchased the building to use as their Motherhouse and St. Joseph Hospital. The building was eventually demolished in 1964 after the hospital moved to Madison Street, where it has grown into today's Provena St. Joseph Hospital.

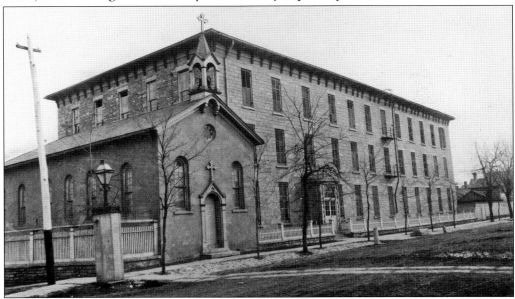

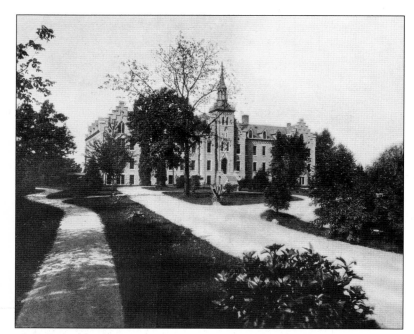

The congregation purchased the 13.25-acre Strong Estate on Plainfield Road in 1880, and a ground-breaking ceremony for the new Motherhouse was held on October 4. The cornerstone of the new convent and academy was laid May 15, 1881, with the congregation taking up residence in May 1882.

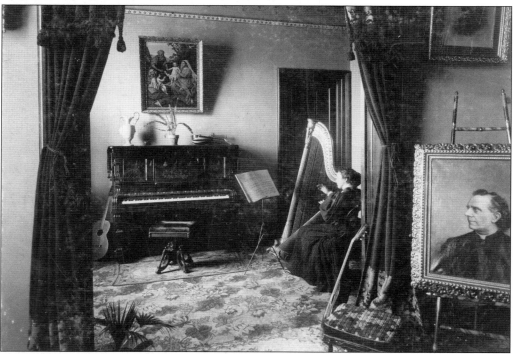

The new Motherhouse on Plainfield Road was larger than the first convent that the sisters left in 1881. The extra space allowed more room for the already established programs and needs, but it also allowed for the addition of new spaces including the front parlor seen here in 1891. The parlor was an area for greeting guests and visitors as well as playing the various musical instruments pictured.

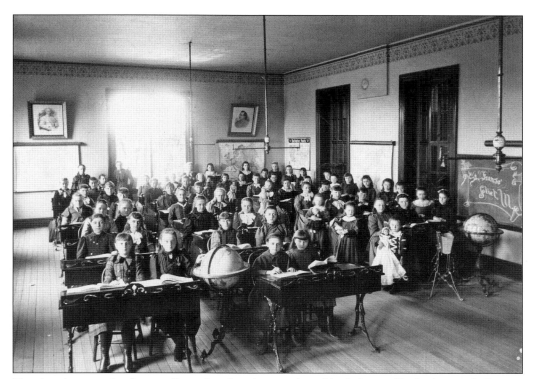

The sister's reputation for excellence in education continued in their new Motherhouse. St. Francis Academy was able to submit materials for exhibits at the World's Columbian Exposition (the Chicago World's Fair) in 1892–1893. The sisters and girls were recognized with the highest award for "30 specimens [of] fancy articles." Here students from various age groups gather together in a classroom in 1892.

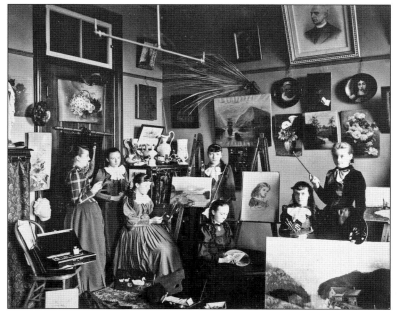

Music and art lessons and studios were a part of the Motherhouse in all its various locations. Mother Alfred, and the sisters who followed her, created arts and crafts as a source of income for the congregation. In this photograph, St. Francis Academy students in Sister Stanislas Droesler's 1892 art class pose in a studio surrounded by arts and crafts created at the academy.

With help from the exposure gained at the 1893 World's Columbian Exposition, the reputation of St. Francis Academy spread to all parts of the United States. Students were enrolled from all parts of Illinois as well as New Jersey, Nebraska, Iowa, Indiana, Wisconsin, Washington, D.C., Ohio, Missouri, New Mexico, Oklahoma, Kentucky, and Kansas, which made creating space for boarding students, such as this typical room, all the more important.

By June 1904, St. Francis Academy had outgrown its building and faculty. The decision was made to close its doors to extern pupils. The sisters continued to provide preparation of teachers for parochial schoolwork and to teach art and music students through their Normal Institute. This photograph of the "Minim Class," the younger group of students, taken in 1904, would have been snapped during the last full academic year.

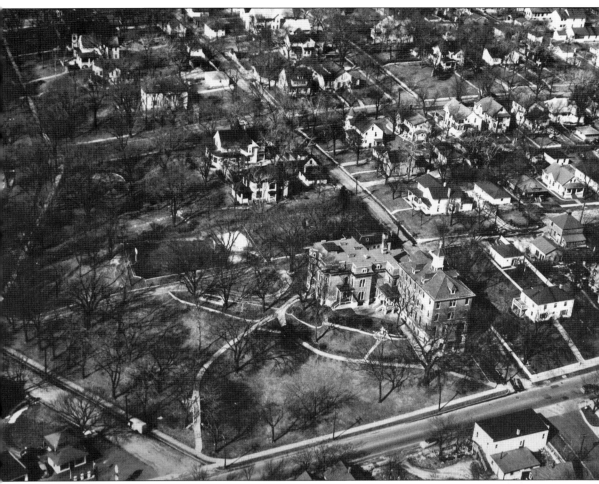

In 1864, orphans began living with the sisters in the Broadway Convent when a fire caused by a lightning strike at St. John Church left the Hartmann children without a mother, and Mr. Hartmann asked the sisters to care for his children. In 1897, an orphanage was founded on the convent grounds to serve neglected and destitute children of Joliet and the vicinity. A small cottage, named St. Joseph's Cottage, was the original home for the children, but as the number of children in their care grew, the sisters recognized that a larger building was necessary. In January 1898, they purchased the Fox Estate on Buell and Charlotte Streets and moved their orphanage to the new location. The house was quickly remodeled, and on October 28, 1898, it was dedicated as the Guardian Angel Home. This photograph shows the orphanage on the estate with Center Street running along the bottom.

In 1912–1913, the sisters added a new wing to the Motherhouse along Taylor Street (below). The City of Joliet, former St. Francis Academy students, and many friends of the congregation helped lift the financial burden from the sisters and enabled them to reopen St. Francis Academy in this new space. The first full schedule of classes resumed in September 1915, and the congregation continued in their desire "to maintain a seminary for young ladies and to promote Christian morals and benevolence" as according to the original charter. The new wing afforded more separation of space between the academy students in the Taylor Street wing and the sisters in the original building (whose door is seen to the left).

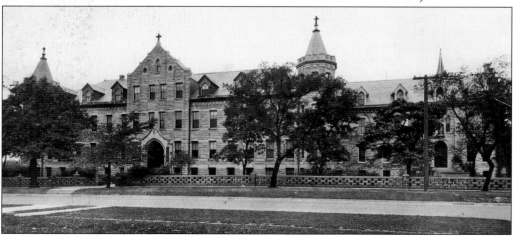

St. Francis Academy classrooms were initially located in the area of the Motherhouse that was the original building, facing Plainfield Road. When the school reopened in 1915 with a new academic wing along Taylor Street, classrooms, like the one pictured here, were relocated to that wing. The wing currently houses the College of Nursing, among other things, and was renamed Donovan Hall in 2009.

The faculty and staff at St. Francis Academy consisted almost entirely of Sisters of St. Francis, which included graduates from the Catholic University of America, University of Illinois, Loyola University, and DePaul University, among others. Even with much of the administration coming from within the convent, the school still had visitors. Guest rooms, like the one seen here in the Taylor wing, were available for their time on campus.

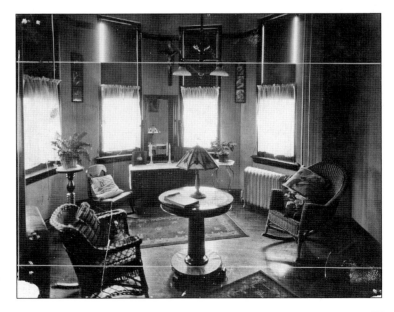

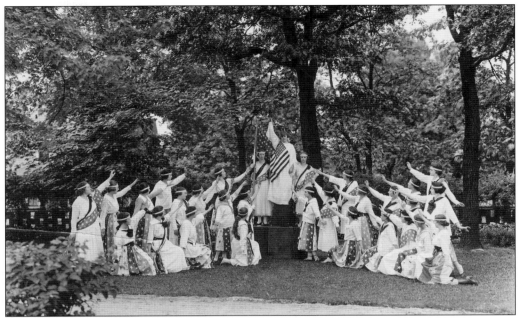

In 1918, Illinois celebrated 100 years of statehood with celebrations throughout the state. Students at the newly reopened St. Francis Academy participated in the celebrations with a pageant. Here students pose in their patriotic costumes on the school grounds outside the Motherhouse.

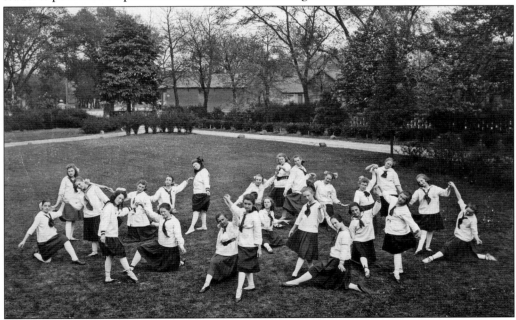

After reopening in 1915, St. Francis Academy became more academically open, widening the boundaries, from what some thought had been a rather exclusive "seminary of learning for young ladies" of the original school Charter of 1874. In this photograph, academy students pose in what seems to be ballet positions on the lawn of the Motherhouse. Dance classes would have been a change from the more regimented physical education classes.

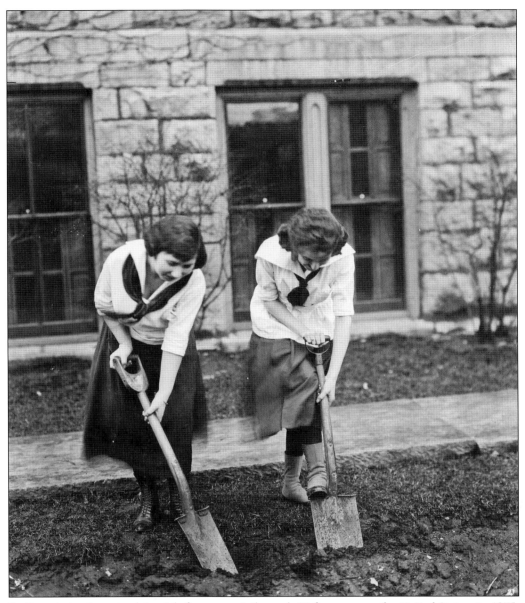

St. Francis Academy took in girls from ages 3 through 20 from across the United States. In 1875, the original plan for the school was to create an extensive new building separate from the convent in an area of Joliet that is now Nowell Park. Mother Alfred had purchased the land and drawn up building plans when Bishop Foley intervened. Before the ground-breaking could take place, the bishop called for the election of a new reverend mother. With new leadership, the plans for the separate building for the academy were canceled. Mother Alfred was sent to Rochester, Minnesota, to build the Academy of Our Lady of Lourdes, and Bishop Foley stepped in, separating Mother Alfred from the Joliet congregation. The sisters were given 10 days to decide if they wanted to stay in Joliet or join Mother Alfred in Minnesota. Those who stayed proceeded with new plans to build the current Motherhouse, a new home for both the convent and the academy. Here two students in 1915 participate in a tree planting near the cornerstone in front of the Motherhouse.

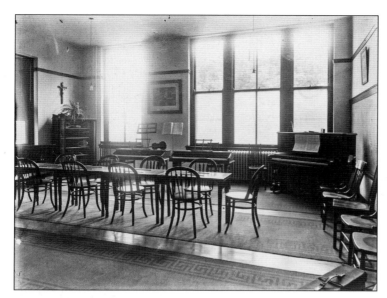

The art and music studios at St. Francis Academy were fully supplied with the instruments, materials, and space necessary for students studying in the departments. Courses included both theoretical and applied portions. The musical technique and training room, seen here, was located in the northwest corner of the second floor of the Taylor Street wing and provided the area needed for art and music students.

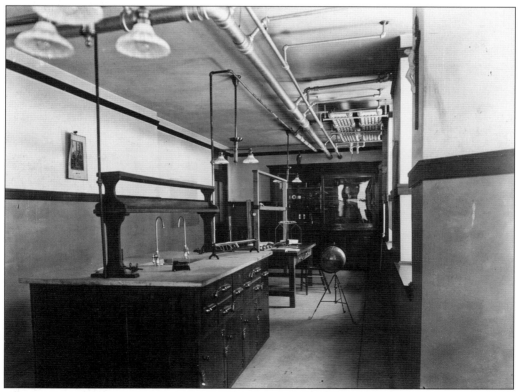

The physics, chemistry, and biology laboratories at St. Francis Academy were well equipped with approved apparatus for demonstration purposes and for individual work necessary in the science courses offered. The biology lab contained a large supply of dried and preserved specimens, maps, charts, and anatomical models. This chemistry lab was located on the first floor of the Taylor Street wing, facing the street.

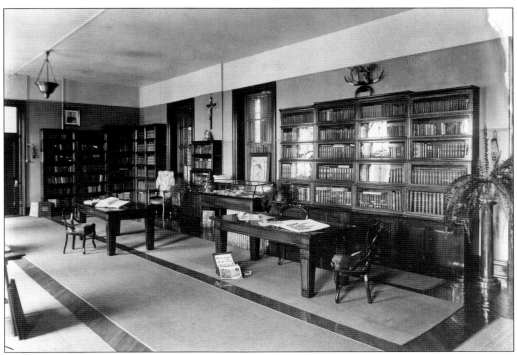

The St. Francis Academy Library was located on the third floor of the Motherhouse in a large room off the chapel corridor, facing Taylor Street. It contained over 10,000 volumes and was well stocked with reference works, encyclopedias, literary magazines, and scientific journals. An arrangement with the Joliet Public Library enabled students to have access to any book in that collection as well.

In addition to the classes offered to students at St. Francis Academy, the sisters also ran commercial schools, which were common in the parishes where the sisters taught. These were the equivalent of a modern-day junior college and specialized in business courses, including typing (as seen in the typewriter lab in the photograph above), shorthand, bookkeeping, and office practices.

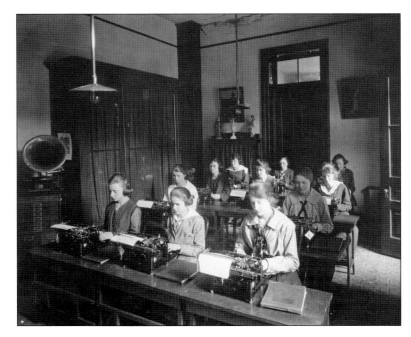

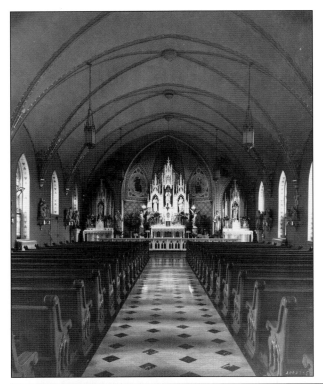

An early brochure for St. Francis Academy states, "The heart of Saint Francis is the Chapel. Not only is the Saint Francis student taught that a chaotic world must return to God and the things of God if it would secure the peace it craves, but she is brought daily in contact with the Source of All Good and the Seat of All Wisdom."

St. Joseph Hospital, run by the Sisters of the Sacred Heart, was located in the building that had been the original Motherhouse for the Sisters of St. Francis. In 1920, the St. Joseph School of Nursing was founded. Students, like those seen in this hospital lab, lived in cottages south of the hospital and attended classes on the ground floor. The School of Nursing became a division of CSF in 1997.

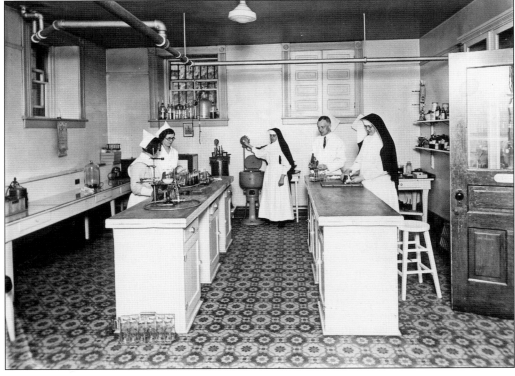

Two

BEGINNING OF
THE TRADITION
1920–1950

Tower Hall was built in 1922–1923 on the corner of Wilcox and Taylor Streets at the opposite end of the campus from the Motherhouse. St. Francis Academy moved into Tower Hall, and the Motherhouse was reorganized to create more space for the sisters' other programs and services. The speeches given during the cornerstone and dedication ceremony for Tower Hall suggested, and even outright asked for, a future college on the site to serve the continuously growing number of girls that desired to study beyond the high school level.

In 1920, the Sisters of St. Francis created a college department limited to those within their congregation, laying the groundwork for a college. When Archbishop Mundelein granted the necessary permission in 1925, the sisters were quick to act. In less than four months, they were ready to open Assisi Junior College. The two-year school experienced an excellent beginning, and in 1930 the sisters easily received accreditation for a four-year college. The school became the College of St. Francis, a four-year, all-girls, Catholic liberal arts college.

The next two decades saw major events occur in U.S. history, including the Great Depression and World War II, which affected the lives of all U.S. citizens, including the sisters and CSF students. But despite these challenging times, the College of St. Francis continued to grow and improve. More departments, majors, and degree programs were added. The faculty was expanded, and the class sizes increased. To create more room for residents, three off-campus houses were purchased, and the college continued its involvement in the community, which afforded the opportunity to use spaces outside the campus for living and activities.

The sisters had held back on taking on any new building projects after Tower Hall was constructed so that they could concentrate on clearing their debts and retaining their good financial status, but with the ever-growing college, they knew that the remodeling and reallocation of space within their current buildings would not be enough to solve their problems. A new tide of building and expansion was coming.

The original 1874 charter from the State of Illinois was amended in 1920 to read, "The object of the Association shall be: to found, establish and maintain institutions of learning devoted to the education of young ladies, and divided into the several departments or Colleges of Liberal Arts, Science, Philosophy, Literature, Fine Arts, Music, Domestic Arts and Sciences, and the various commercial branches." The sisters responded to this new charter with the construction of Tower Hall in 1922 (below). This new charter and new building laid the foundation for creating a college for students to study beyond high school. When Assisi Junior College officially opened its doors in 1925, it was recognized that the school would need its own separate leadership; Mother M. Thomasine Fryewska (left) was the first president of the school, serving from 1926 to 1938.

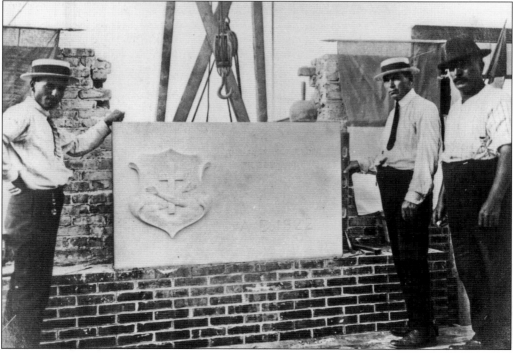

Tower Hall was built in 1922–1923 on the corner of Wilcox and Taylor Streets. The building was created to be the new home of St. Francis Academy with more space for classrooms, offices, and residents. The building was celebrated at all stages of its construction. A parade through Joliet was held for the ground-breaking ceremony on May 17, 1922, and another Joliet citywide event celebrated the laying of the cornerstone. On October 13, 1923, Joliet mayor George Sehring spoke at the building dedication, petitioning Archbishop Mundelein directly with these words: "The citizens of Joliet are proud of this educational institution and I wish to convey their sentiments in asking your permission which will enable the Sisters to open a Junior College course in addition to their present educational system."

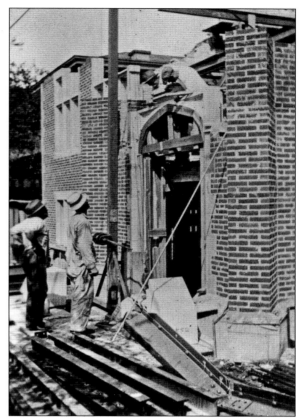

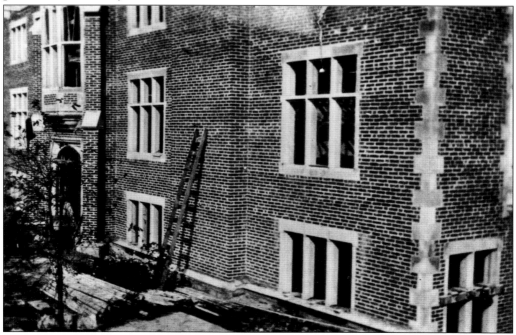

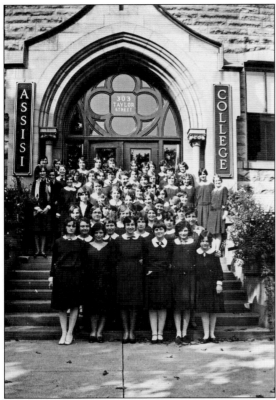

On June 13, 1925, almost two years after Tower Hall was dedicated, Archbishop Mundelein granted the necessary permission for the congregation to open a junior college. The sisters acted quickly, calling Sister Alcantara Held back from Columbus, Ohio, to be the first academic dean. A brochure and mini-catalog were drafted for the "New College," and on September 8, Assisi Junior College opened with 13 students enrolled.

Assisi Junior College was officially organized and established in less than four months during the summer of 1925 but was a long awaited addition to the educational institutions of the congregation. Students like those seen here gathered around the Grotto of Our Lady Lourdes throughout the years, and the creation of an official college meant more students to extend that tradition.

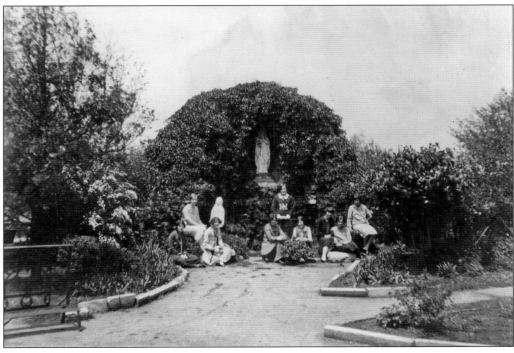

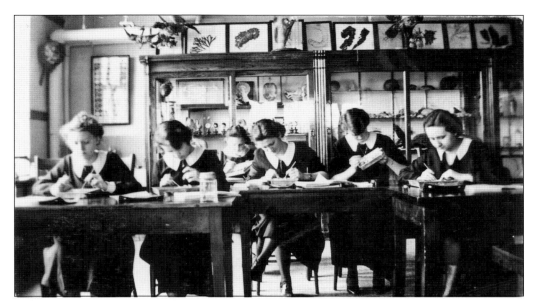

Students in an early science class work on individual dissection projects in a well-equipped lab in Tower Hall. Until around 1964, college students were required to wear a uniform of a black, one-piece dress with a removable white collar and cuffs while attending classes and chapel services during the day.

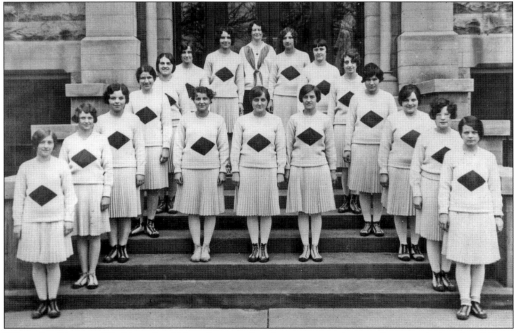

When the Sisters of St. Francis of Mary Immaculate began accepting students to their school from outside the congregation, the two-year college became known as Assisi Junior College. Assisi offered courses in literature and arts, education, and general business, and every student was required to take a physical training class their freshmen year. The students pictured here are from the freshmen gym class in 1928.

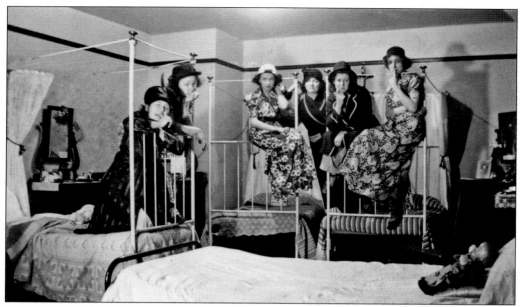

In the 1930s and 1940s, dorm rooms at USF were located in Tower Hall. These early rooms were a variety of sizes. Students could be assigned to single, double, triple, and quadruple rooms or even dorm rooms with five bunk beds for 10 students. Here students around 1937–1938 show their lighter side, posing in room 423 on the dorm furniture, wearing dressing gowns and hats.

Assisi Junior College experienced an excellent beginning, and in 1930 the sisters easily received accreditation for a four-year college. The school title was changed to the College of St. Francis and began to focus on functioning as a liberal arts college. CSF students, like those seen here studying in a Tower Hall lounge, were now given a wider range of studies, as their education became a four-year curriculum.

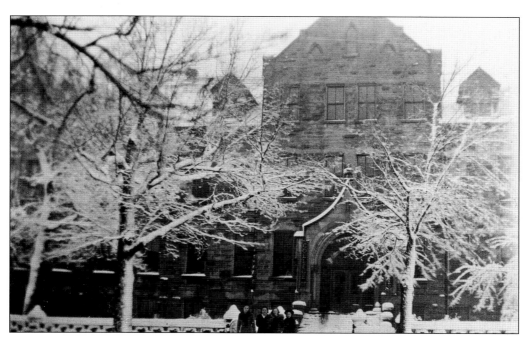

An early brochure for the college stated, "The site of the College is one of the most picturesque in Joliet and the vicinity. The building, nearly in the center of a tract of 14 acres, is free from the distractions and annoyances of close proximity to public thoroughfares. The classrooms and halls are bright and cheerful." College students stand outside the bright and cheerful building's main entrance at 303 Taylor Street.

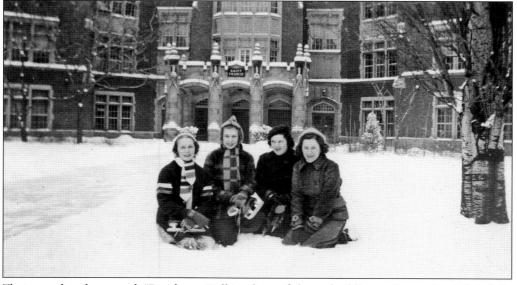

That same brochure read, "Residence Hall is a beautiful new building and contains delightfully homelike rooms. The all-around college girl will find her ambitions regarding study, piety, athletics, and social affairs materialized in Residence Hall, for here are found study rooms, the chapel, the gymnasium, and reception rooms." Some of the ambitious students take advantage of the snow in front of Tower Hall during the winter of 1937–1938.

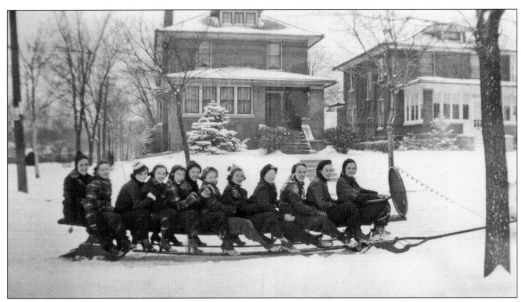

The development of students in all aspects of their lives was always a priority for the Sisters of St. Francis. A wide variety of opportunities and extracurricular activities were offered to students in order to enhance their spiritual and social welfare. In this photograph, a group of students take a toboggan ride north on Wilcox Street during the winter of 1937–1938.

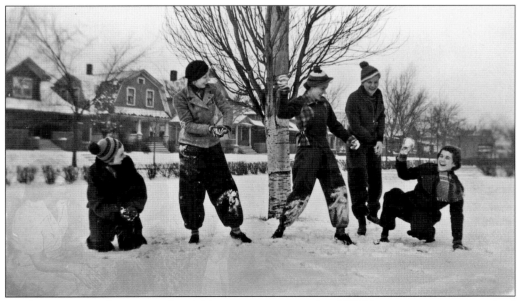

Outdoor sports and intramural activities were encouraged at CSF. There were some organized and regimented activities as a part of the school's educational requirements, but spontaneous gatherings, such as this snowball fight held on the front lawn of Tower Hall in 1937, were also fun additions to the students' schedules.

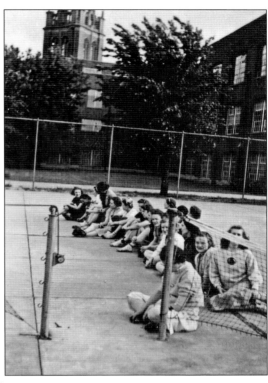

From the beginning days of the school, athletics were a mandatory part of the educational program. Assisi Junior College students were required to take a physical training class during their freshmen year; this requirement continued when the school became the four-year CSF. In the photograph at right, students sit on the campus tennis courts during a gym class. The photograph below shows two students pausing for an apple break during a friendly tennis match. These tennis courts were located on the campus grounds north of Tower Hall along Wilcox and Douglas Streets, which is the current location of the main parking lot on campus.

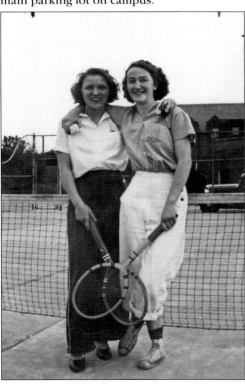

A variety of organizations and clubs were created at CSF to ensure that students had a wide range of opportunities in addition to studying. Students could join student government, sodality, Theta Chi Sigma sorority, the Women's Athletic Association, or a variety of honor societies among other things. The students in this 1938 picture are having an informal game of leapfrog, using the lawn on the quad outside the Motherhouse.

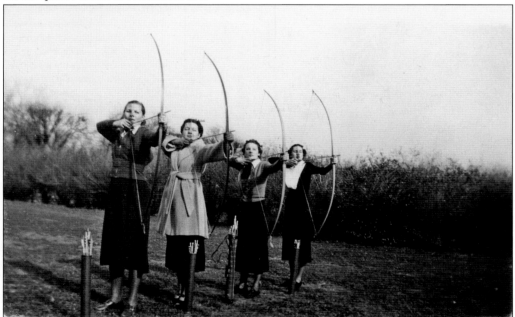

In addition to the educational courses and extracurricular activities, like this archery class held during the 1936–1937 academic year, CSF paid attention to the social life of its students. According to the original announcement booklet from 1930, "Parties, formal and informal, teas, receptions and other forms of entertainment are held occasionally for the purpose of acquiring the ease and charm that should characterize such affairs in the future life of the student."

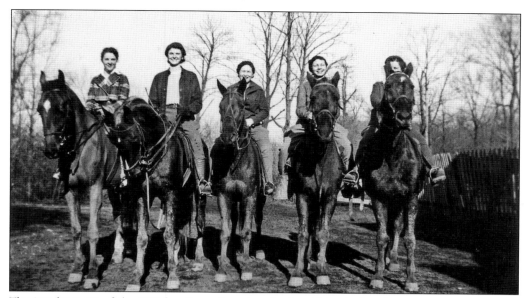

The involvement of the CSF faculty and student body within the local community was evident from the school's beginning. The school shared and borrowed space all around the city for activities that could not be contained within the campus, such as this 1935 Riding Club outing. In academics, writings of CSF students were featured in the *Joliet Herald News* in 1936 during the celebration of Will County's 100th anniversary.

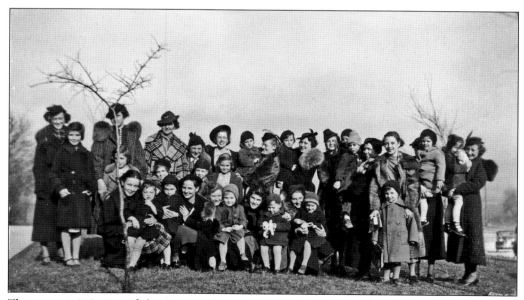

The many ministries of the Sisters of St. Francis had opportunities to interact and overlap. Students from the College of St. Francis hosted an annual Christmas Party for the orphans at the Guardian Angel Home. This 1936 photograph shows the students and children together on the lawn outside the home.

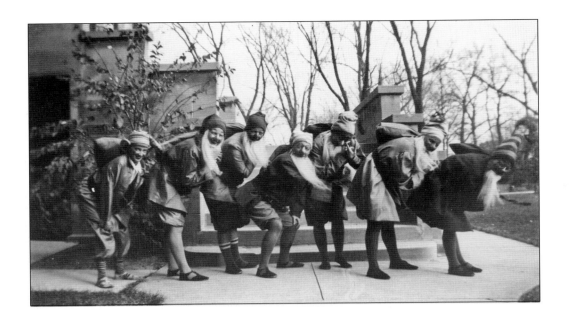

In 1933, CSF produced *Il Poverello*, a musical theater production based on the life of Saint Francis of Assisi. It was a benefit performance for the Guardian Angel Home and had a cast of 350 participants chosen from all over the city of Joliet. This was only one in a long line of theater productions put on at CSF. Some were done completely in-house, while many had students from other schools or members of the community as a part of the cast. The "seven dwarves" in the above photograph are CSF students from the *Snow White* production of 1938, while the swashbucklers in the photograph below are men from outside CSF cast as pirates in *The Pirates of Penzance* production of 1937.

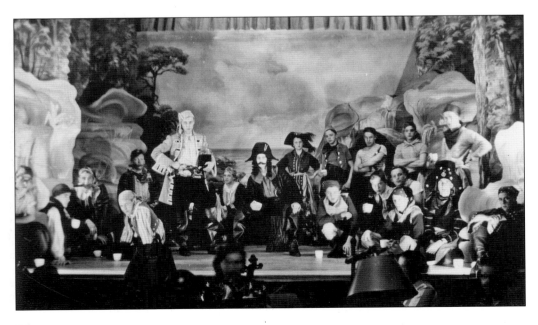

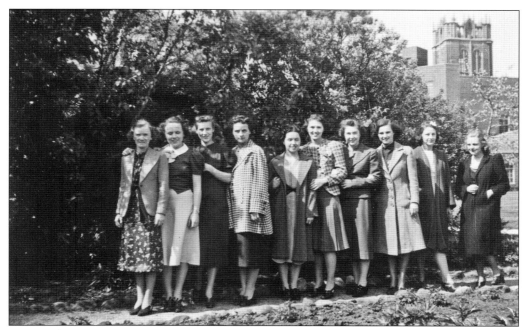

In 1939, the Great Depression was nearing an end and the United States had not yet entered into World War II, making this an era of lightheartedness and optimism at CSF. Seniors from the class of 1939 enjoy the spring weather out on the quad. From left to right are Evelyn Mintert, M. Ruth Kerper, Margaret Zabrowski, Olive Pommier, Patrice McShane, Marie Ribordy, Novita Moddrel, Minola Williams, Elizabeth Assell, and Frances Fencel.

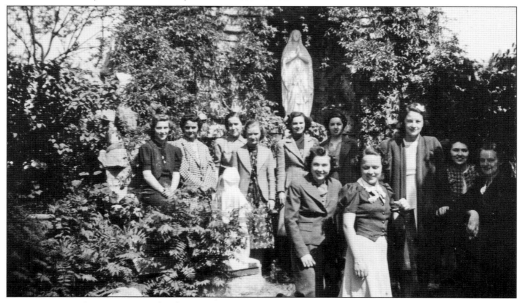

As CSF grew, the sisters worked to maintain the school's Franciscan identity, holding on to the ideas of simplicity, sincerity, hospitality, and joy. Students from the class of 1939 stand by the Grotto of Our Lady of Lourdes in the Quad. Devotion to Mary is dear to the heart of Franciscans, and the Grotto, which is still standing today, helped to maintain CSF's Catholic identity.

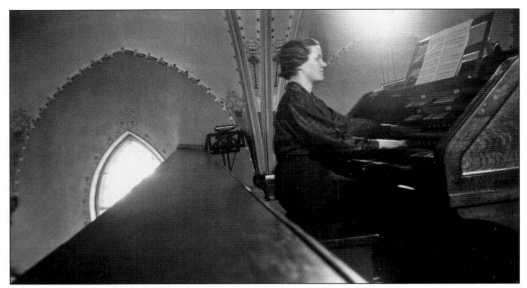

The current organ in the Motherhouse St. Joseph Chapel was dedicated in 1931, a gift from the former mayor of Joliet, Sebastian Lagger. It was used for services and events held in the chapel as well as accompaniment during practices and performances of the music department. In this photograph, CSF student Wilhelmine Hammel ('36) plays the large instrument during the 1934–1935 academic year.

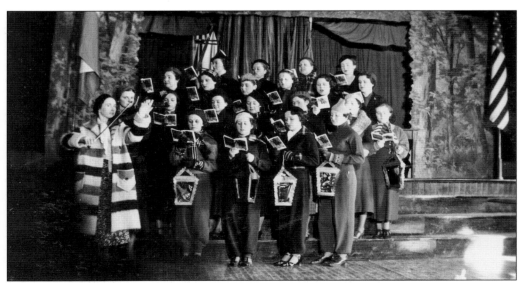

The Assisi College School of Music began as a school separate from Assisi Junior College but was quickly integrated as the department of music. The purpose of the school was to offer a means of artistic and intellectual culture to those seeking a general education and also to provide a thorough training for students who wished to become music teachers or concert artists.

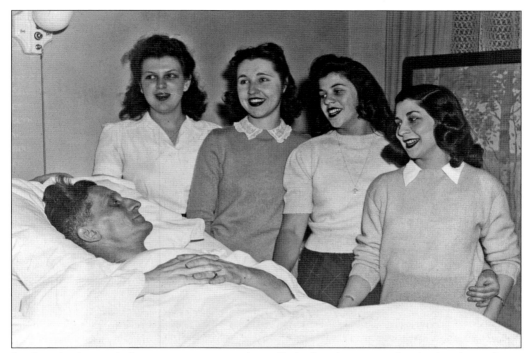

Students in the music department were not always limited to the campus for sharing their talents. During the 1946 Christmas season, 39 carolers from the college visited several Joliet institutions. The students pictured here are, from left to right, Dorothy Martinovich ('48), Hilda Cushing, Lou Ann Madden, and Marie Semling ('46). They are serenading St. Joseph Hospital patient Richard Manz.

The Assisi College School of Music was located in Tower Hall on the third floor of the wing along Wilcox Street. There were 20 practice rooms equipped with pianos for voice, harp, violin, piano, or cello. There was also an informal recital hall used as classrooms and ensemble rooms. Members of the Choral Ensemble or Glee Club, like these caroling in 1946, used the rooms for their practice sessions.

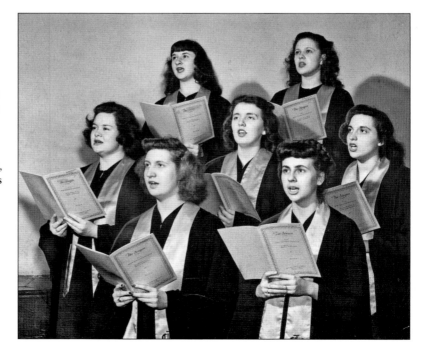

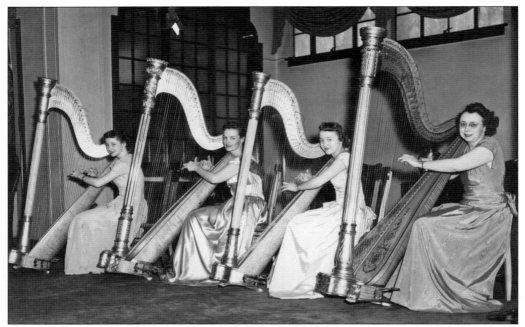

Sister M. Charles Zieverink was a professor in the College of St. Francis music department for 38 years. She was an accomplished harpist and influenced the development of the school's music program. The students pictured here are taking part in a recital with Sister Charles as both their teacher and accompanist.

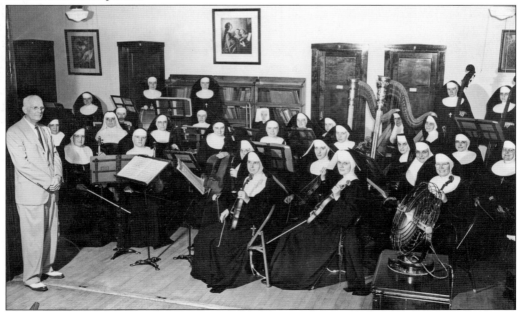

The all-sister orchestra was organized during the summer session at CSF in 1949. The 30-member group was made up of music teachers from more than one order, although 21 musicians in this photograph are Sisters of St. Francis. The orchestra was directed by Hiram A. Converse (far left), a well-known conductor from the Joliet Township High School orchestra.

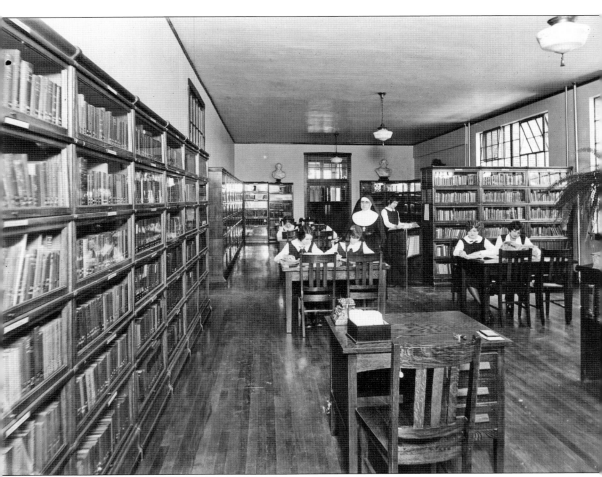

The North Central Association of Colleges and Universities accredited the College of St. Francis in 1938. The school rejoiced, and Mother Thomasine proclaimed this as the "end of the beginning of CSF." With this major achievement, she handed the reins over to Sister Aniceta Guyette, second president of CSF. Sister Aniceta was a librarian before she took over the role of president, a position she held until 1953. In this photograph, she is pictured overseeing St. Francis Academy students as they work in the library in Tower Hall. Once the college opened, two libraries were created, one in Tower Hall and one in the Motherhouse, in order to serve the needs of both academy and college students.

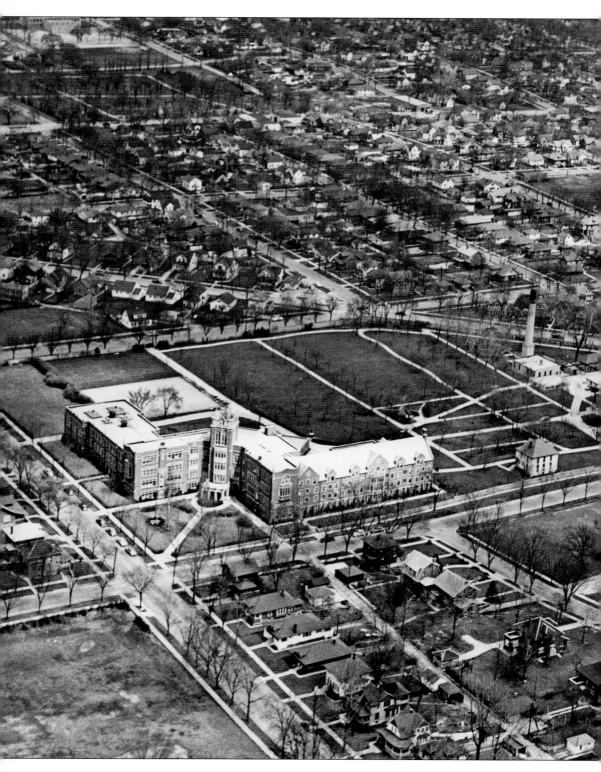

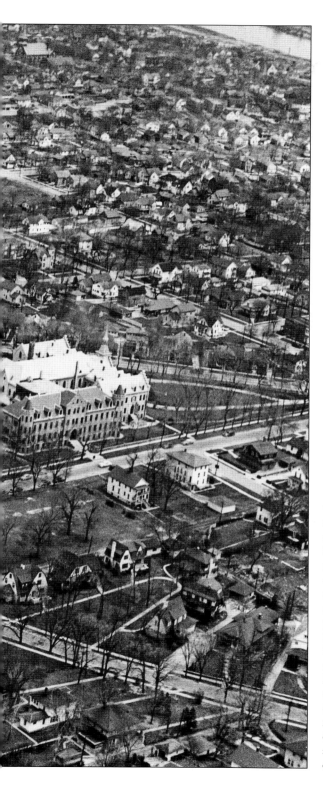

Within 50 years of the Motherhouse cornerstone being laid in 1881, the Sisters of St. Francis sponsored four major building projects in order to continue the missions and functions considered central to their congregation. This aerial photograph, taken around 1940, shows two of those completed building projects, the Taylor Street wing of the Motherhouse (right) and Tower Hall (left). The combination of the debt taken on to complete the projects and the precarious financial status of the nation caused the sisters to manage their funds cautiously during the next few decades. Small remodeling projects took place in the chapel, the auditorium, and the porchways, and rooms were reallocated to meet the ever-pressing needs for space.

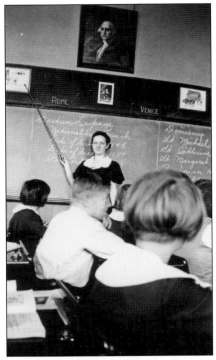

The original purpose of the congregation of the Sisters of St. Francis was the education of youth. The community's educational services began even before the congregation was officially founded in 1865. By 1940, more than 500 sisters were actively engaged in 51 elementary schools, 17 high schools, and one college. The College of St. Francis had a vibrant education department that was one of the original programs offered when the school first opened. The first teacher's certificates were given in 1926, and the department grew from there. Education students, like the ones seen in the photographs (left, around 1934–1935; below, around 1956–1960), were given the opportunity to spend time as student teachers within classrooms at schools in the Joliet area.

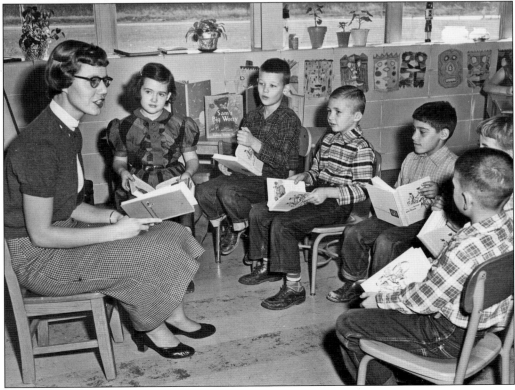

The College of St. Francis had been a four-year college for only a decade when these students returned to school in August 1941, but it was already gaining the knowledge and prestige necessary to make it a premier Catholic liberal arts institution. The school guidebook from 1933 states, "The end and aim of all training is to develop a character which shall be strong and virtuous."

Sister M. Claudia Zeller (left) taught in the mathematics department for 30 years, and the Zeller Conference Room on the second floor of Tower Hall was named in her honor in 1996. Here she plans the program for the first reunion meeting of the IL Delta Chapter of Kappa Mu Epsilon, a mathematics honor society, with alumnus Joan (Nahas) Ramuta ('56, second to the left) and students Marlene Schaab ('59, seated at right) and Anna Marie DiMonte ('59).

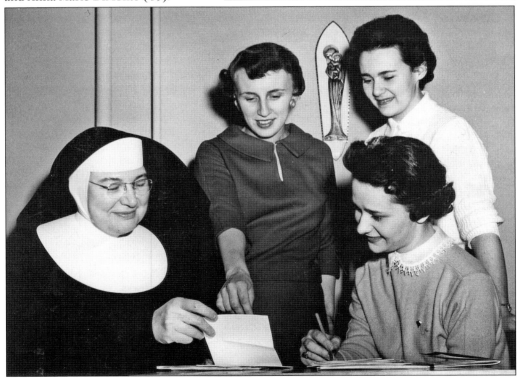

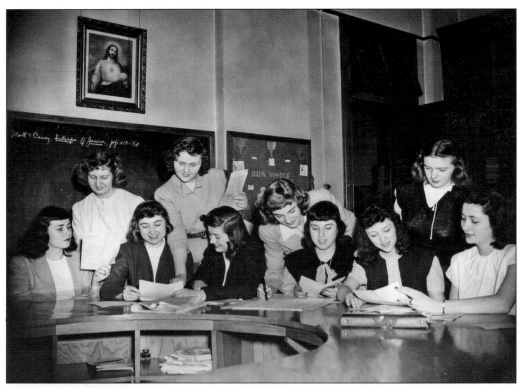

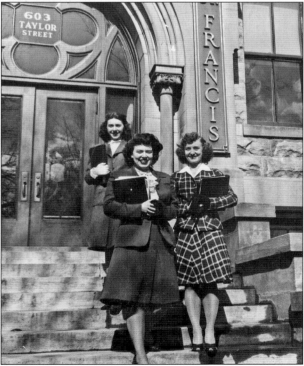

The school newspaper was a popular extracurricular activity for CSF students. The paper ran from 1925 to 1969 as *The Interlude* and from 1976 to the present as *The Encounter*. In 1947, *Interlude* coeditors (standing) oversaw students working on the freshmen edition; for this yearly edition, freshmen took over the three departments—circulation, business, and editing.

CSF students were able to take advantage of the school's connections in the community in order to obtain experience outside the classroom. These prospective social workers, Mary Catherine Cox ('46), Catherine Tracy ('46), and Lucille Augulis ('46), were junior sociology students in 1944–1945 when they were photographed heading off to in-service training with local service agencies.

In October 1949, the art department hosted a student art exhibit in Tower Hall. The exhibit cochairwomen, Mary Hoyt and Margaret Carrigan ('50), are pictured holding some of the items that would be displayed. With the creation of the art major in 1944, students were given more opportunities to create, and the school took the opportunity to showcase the talent of their students.

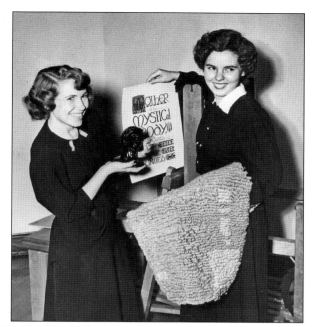

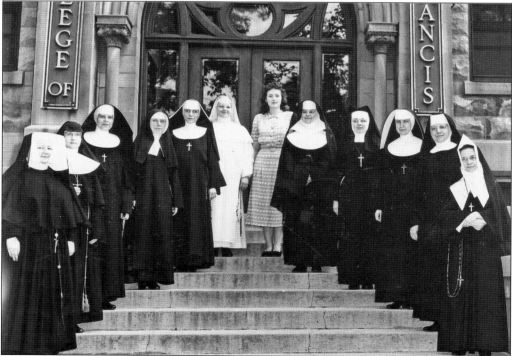

A wide range of students attended summer sessions at CSF. Posing on the steps of the Motherhouse are students representing these various groups. Pictured are, from left to right, Sister M. Grace Esther, BVM; Sister Mary of the Annunciation, SSCM; Sister Dominic Marie, OSF; Sister Bernella, OSF (Indiana); Sister M. Placida; Sister M. John, OP; Mary Catherine Steen ('50); Sister M. Daniel, SM; Sister M. Rosanna, Felician; and three unidentified women.

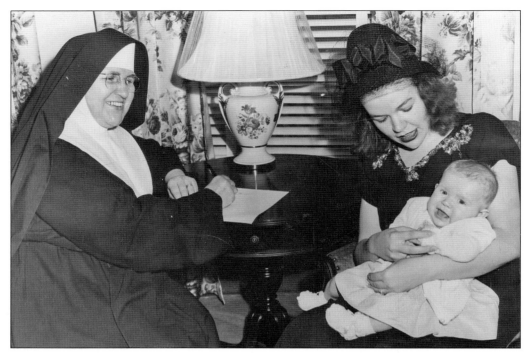

Sister Aniceta Guyette was the second president of the College of St. Francis, serving from 1938 to 1953. Her tenure brought new fields of study for CSF students with the introduction of four new majors and two new bachelor degrees in 1943 and 1944. In this photograph, Sister Aniceta meets with Margaret (McCorriston) Lauderdale ('45), who brought her four-month-old daughter, Maureen, to "register" her for classes.

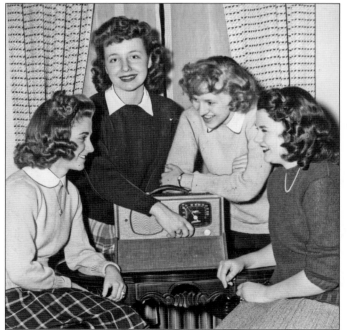

Students used radios in addition to newspapers to keep up to date on what was happening around the country and the world. In this 1943 photograph from left to right are freshmen class officers secretary Appa Jean Moyemont, president Joan Young ('47), vice president Mary Ann Klimek ('47), and treasurer Gail Dorigan ('47) tuning in to news of victories in the Marshall Islands and in Italy, each having a brother in the service.

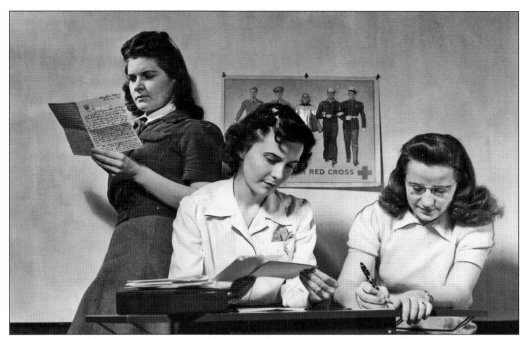

Around 1945, CSF students formed the Writing Sixty-Ninth, which wrote letters to service men on the fighting front and the training fields during World War II. The name of the group was a play on the 69th Infantry Regiment, a military unit from New York City that was often called the "Fighting Sixty-Ninth." In 1940, the film *The Fighting 69th* was released, which dramatized their exploits during World War I.

These students are watching as an air corps training flight roars overhead. During World War II, the college did its part for the war effort by selling war bonds, making bandages, providing childcare for mothers who had war-related jobs, and helping residents of Joliet compute fuel rations. The school also added new courses, such as a history course covering the Far East and the Pacific, which related to the war.

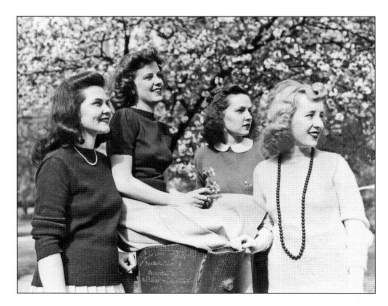

Dinner at CSF was a formal affair. The meal began promptly at 6:00 p.m., and students were required to wear proper attire, changing from the black crepe dresses with white collars that were the uniforms worn during the day. Students were coached on correct manners and etiquette and were expected to use the dinner hour to show their skills.

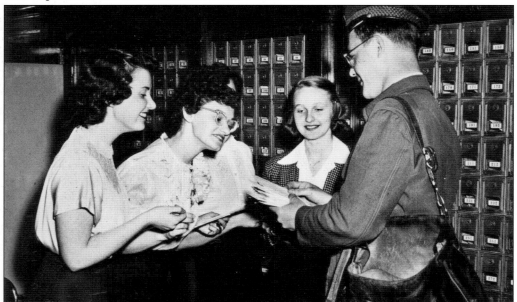

These eager students met the mailman in order to receive their letters as quickly as possible. For residents at CSF, before the age of e-mail, the postal service was the main way to communicate with friends and family in other places. The mailboxes for college residents were located close to the front doors of Tower Hall in the area that is now the Uno Lounge.

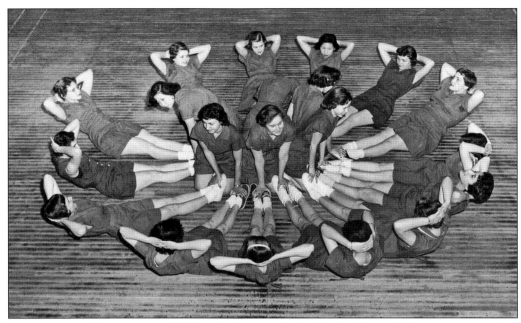

The lack of recreation facilities on campus did not stop physical education from continuing to be a part of the curriculum at CSF. This photograph shows students working together in gym class to do sit-up exercises. They used an area in Tower Hall called the Atrium. This area was two stories with a balcony and was used as a multipurpose room. The cafeteria is now in this space.

The Women's Athletic Association (WAA) was formed as an adjunct to the health programs at CSF. The WAA held tournaments in seasonal sports, organized monthly outings, and planned an overnight camping trip each semester. In this photograph, the students are, from left to right, Gen Vrdolyak ('46), Rosemary Federer ('46), Dorothy Wind, Lucille Augulis ('46), and Nan Miles ('47). They are gathering the necessary items for an overnight hiking trip hosted by the WAA around 1945.

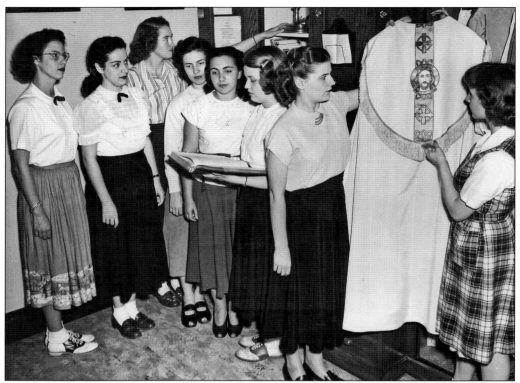

One activity that some students were able to participate in was becoming a sacristan, or a student who maintained the sacristy and the sacred objects within. The students pictured here in October 1948 are gathered in the sacristy so that the old sacristans could review the duties with the new. The work was shared on a weekly basis.

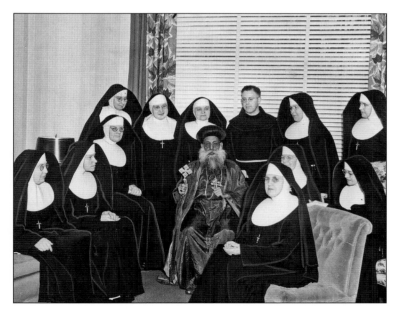

In January 1948, His Excellency Archbishop Mar Ivanios of the Metropolitan of Trivandrum, India, came to Joliet to visit with faculty members of the College of St. Francis. He was in the process of planning a college in his native city and asked the sisters for information on setting up successful Catholic schools. He is pictured here after the formal conference.

The graduation ceremony at CSF was often a multisite affair. Graduates gathered in a separate location and then marched across campus to the St. Joseph Chapel in the Motherhouse. The graduates in this photograph are from the class of 1949. When St. Raymond's Cathedral was completed in 1954, its close location and abundance of space made it ideal for hosting graduation ceremonies that accommodated the growing class sizes.

Like many schools, the College of St. Francis's graduation ceremony changed and shifted as the years passed, but the school always remained tied to its Catholic identity and Franciscan roots. For the graduation ceremony in the spring of 1946, Card. Samuel Stritch, archbishop of Chicago, presided over the handing out of diplomas. In this photograph, he is handing a diploma to the kneeling Gen Vrdolyak.

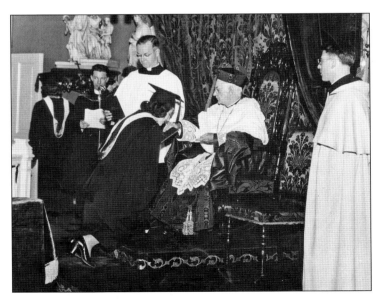

In addition to the graduation ceremony, CSF also held an Honors Day Celebration at the end of the spring semester. Honors Day celebrated students who excelled in various areas, giving recognition for their achievements. The highest honor, until 1960, was to be named Miss St. Francis. In this 1950 photograph, a marching band leads the procession during the festivities.

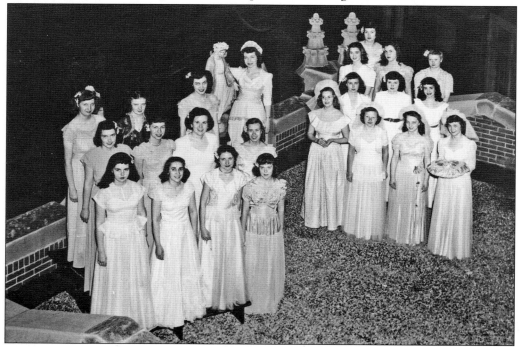

The College of St. Francis, like many other Catholic schools, held a May Crowning Ceremony during the month of May. The tradition includes a procession, pretty dresses, and a wreath of fresh flowers that one student places on the statue of Mary. Participants in this 1947 ceremony stand with the statue on the roof of Tower Hall.

The College of St. Francis continued to grow as the decades progressed, drawing students from all over Illinois and other parts of the country. This photograph from September 1945 shows six freshmen newly enrolled at CSF who came from six different archdiocesan high schools. Pictured are, from left to right, (first row) Elaine Fellios, Helen McCloskey, and Elaine Cheruski; (second row) Vivian Whitehead ('50), Rosemary Lucas ('49), and Mary Virginia Morse ('49).

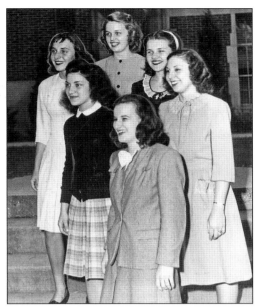

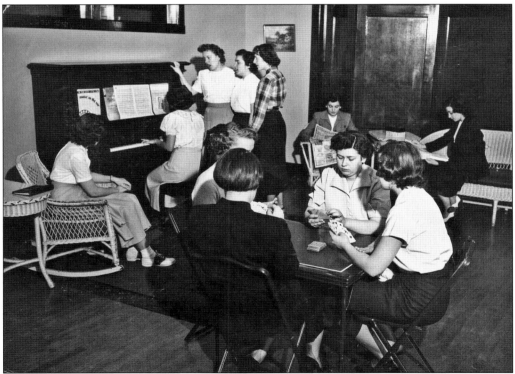

Although student schedules included formal study hours during the evenings, there were plenty of opportunities to relax and socialize on campus. Students in this 1949 photograph are participating in a variety of activities in the Saint Charles Lounge in Tower Hall. Singing, playing, or listening to music, playing cards, and getting caught up on the latest news in the newspaper were common activities.

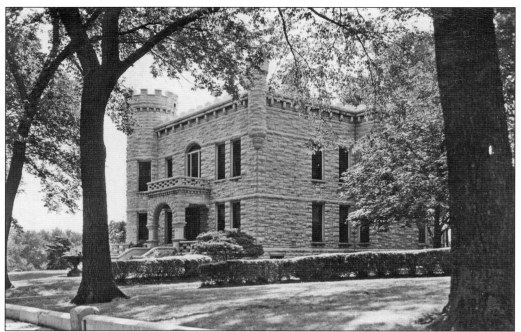

In the 1940s, a temporary solution to space problems was to purchase off-campus buildings for student housing. Three large homes on Bridge Street were acquired in 1946 and 1947. Marian Hall, the former residence of George Sehring, housed 16 seniors and two sisters, while Angela Hall (below), the former residence of Henry Sehring, housed 15 juniors and two sisters. The Sehring Castle (above) was the third home acquired from one of Joliet's first families and housed 14 students and two sisters. During the 1880s, Fred Sehring, the family patriarch, worked with an architect to design and construct all three homes. Fred's son George was a former mayor of Joliet and a major proponent of the opening of a college, even mentioning it in his speech during the cornerstone ceremony of Tower Hall. All three of these historic homes are still standing.

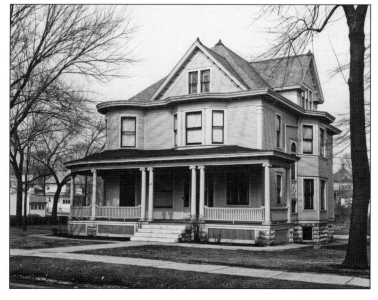

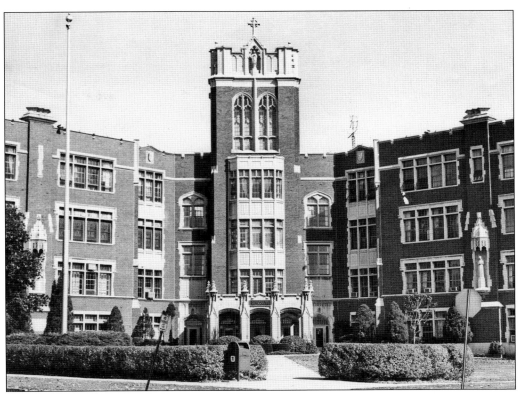

Pictured is Tower Hall with the Tower of the Immaculate Conception in the middle. When Tower Hall was still "new," it was often called Residence Hall because most CSF resident students lived there. The other main building on campus was the Motherhouse. In addition to housing the library, the Motherhouse was also the location of most classrooms and laboratories, leading it to be called the Scholastic Building.

The Motherhouse, or Scholastic Building, was the home of the CSF Library until 1968. The library was open during the day and then during formal study hours in the evening with limited hours on the weekends and holidays. The area was constantly in use, whether for academics or pleasure. This entrance, facing Taylor Street, pointed the way for both students and visitors alike.

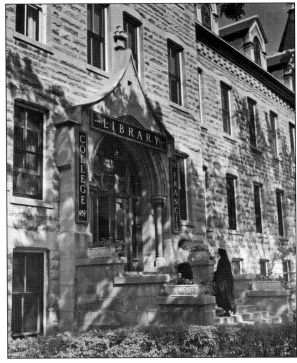

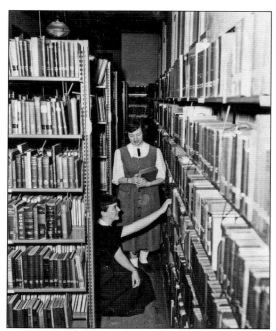

The library in the Taylor Wing of the Motherhouse was quickly becoming too full. Over the years, the room had been shifted and adjusted to create more space for students and materials, but with the continuously increasing class size, space was running out. The students in this 1956 photograph show the typical issues faced when trying to locate a book in the crowded stacks.

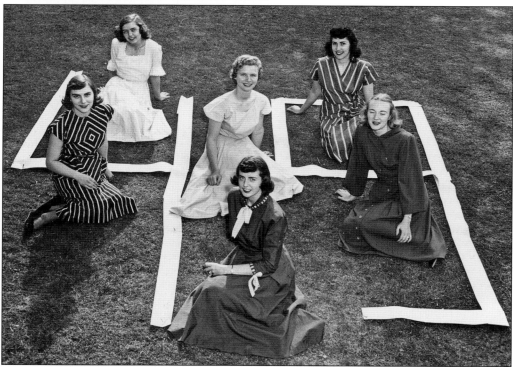

It had been almost five years since the end of World War II, and the country had a new president in Harry Truman. The exciting new world of television was starting to blossom and a woman, Margaret Chase Smith, was the first woman to be elected to both the U.S. House and Senate. Members of the class of 1949 declare their class spirit, ready to face the exciting future outside CSF.

Three

THE BUILDING ERA
1950–1970

The period between 1950 and 1970 at CSF was known as the "Building Era." No major building project had been undertaken since 1926, but the time had come to expand the facilities on campus. In 1953, the sisters added a third wing to the Motherhouse, called the Novitiate, which was used to house the increasing number of young women entering the congregation. Even with this new space, there was an immediate need for more room; in 1955, Tower Hall was expanded along Taylor Street towards the Motherhouse in order to provide living quarters for the sisters who were working at the college. One of these sisters was Sister Joan Preising from the chemistry department, who made it her personal project to raise the money for a new science building. Because of her hard work and the school's determination, St. Albert Hall became the third separate building on campus in 1959.

In addition to the new buildings, the 1950s found the college expanding its academic areas. The school opened a reading center in 1954 and a language lab in 1956. Off campus it began teaching medical technology courses in 1953 and formed cooperative television programs with Midwest Program on Airborne Television Instruction (MPATI) and Chicago PBS station WTTW in 1957. The school's adult courses expanded to include evening and Saturday classes in 1959.

One of the most important events of this time period took place October 22, 1962, when the college was officially incorporated as its own institution separate from the congregation. This incorporation provided access to federal and state grants, prompting the school to continue on its mission to build the necessary facilities. A new, ambitious building program was announced that included an auditorium, a residence hall, and a separate library. The first building to be completed was Marian Hall, a residence hall completed in 1966 that provided room for an additional 250 on-campus residents. The library project quickly followed and was finished in 1968 with almost four times the space of the old library in the Motherhouse. The auditorium project was postponed and finally abandoned, although the desire for a new fine arts facility was never forgotten.

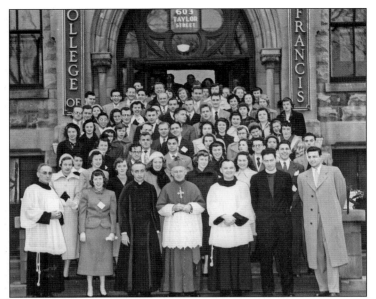

In 1951, the regional Mariology Commission of the National Federation of Catholic College Students (NFCCS) sponsored the Marian Congress held at the College of St. Francis. The congress included both speakers and panel discussions all focused on Mary, the mother of Jesus. The delegates pictured here on the steps of the Motherhouse came from nine area colleges and were addressed by Bishop Martin D. McNamara (front row, center).

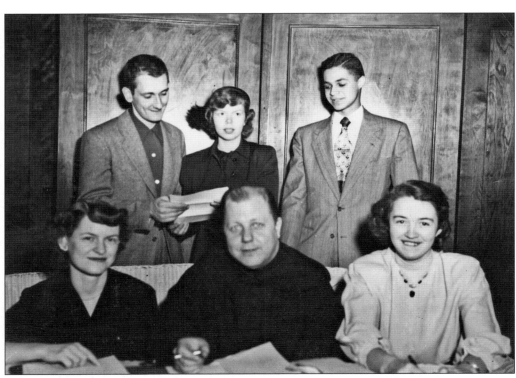

The Marian Congress was an annual event that aimed to foster love and service of Mary, the mother of Jesus, through knowledge of her. In this photograph are members of leadership for the 1951 event. Pictured are, from left to right, (first row) Rita Guertin, cochairman; Fr. Norman Werling, O.Carm., clerical advisor; and Mary Weigand ('51), cochairman; (second row) Jerry Walling, Rita Butler, and Thomas Simmons, all discussion members.

Bishop Martin D. McNamara (right) presided over the graduation ceremony on May 30, 1951, with the help of Fr. Cyril Shircel, OFM (left). Bishop McNamara was the first bishop of Joliet from 1948 until his death in 1966 and was also the chancellor of the College of St. Francis. In 1951, there were 23 students that graduated, including Ann Flynn (pictured kneeling), who was crowned Miss St. Francis.

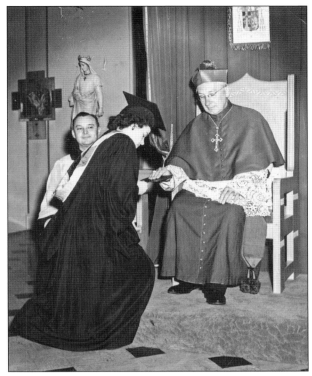

The Joliet Diocesan School Meeting was held at the College of St. Francis in 1952. Some of the meeting attendees included, from left to right, Sister Chrysantha Hoefling, dean of studies; Sister Mercedes Vollmer, school supervisor; Bishop Martin D. McNamara, bishop of Joliet; Bishop Fulton Sheen, auxiliary bishop of the Archdiocese of New York and radio and television host; and Sister Aniceta Guyette, college president.

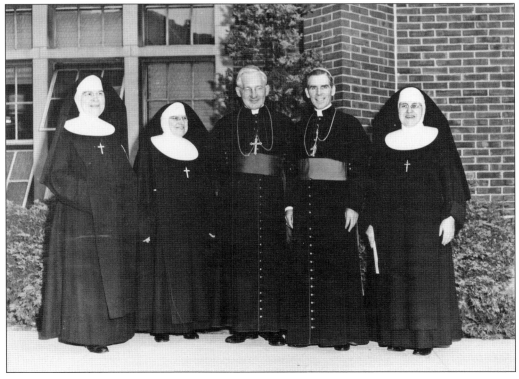

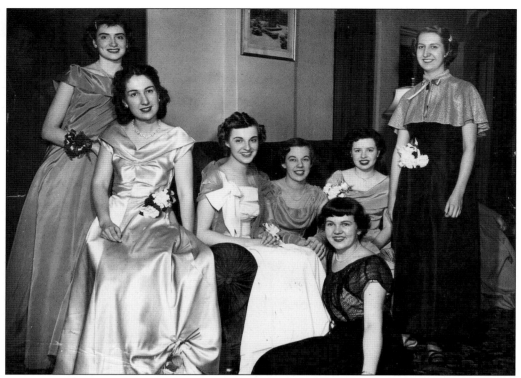

The social lives of students at the College of St. Francis included many opportunities to mingle with other students, such as teas and receptions held on campus, but there were also opportunities to socialize with people off campus. The prom was one of the largest events held each year. Because of the large size of the gathering, a hall or hotel ballroom off campus was usually reserved to afford ample space for socializing and dancing. The students seen dancing with their escorts at the junior-senior prom in 1954, seen below, are possibly at the Knights of Columbus Hall, the current home of the Big Brother, Big Sisters organization. The students in the photograph above are posing for photographs in a lounge on campus before heading off to the 1950 prom.

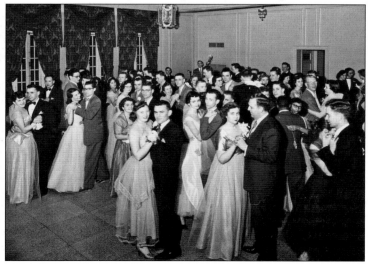

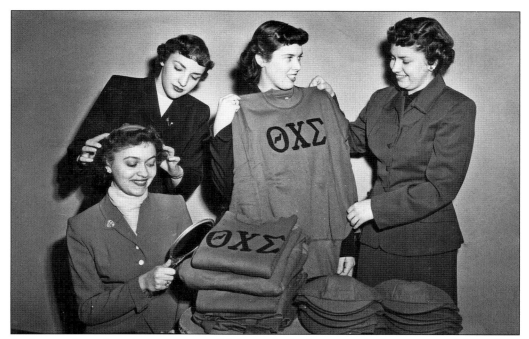

As the number of students grew, so did the variety of extracurricular activities. The college encouraged students to become involved in something outside their classroom routine, proclaiming, "Each club has something to offer either religiously, scholastically, socially or morally." The Theta Chi Sigma Sorority was one of those clubs; here students in 1953 try on the red and black sweaters and caps used for the formal initiation.

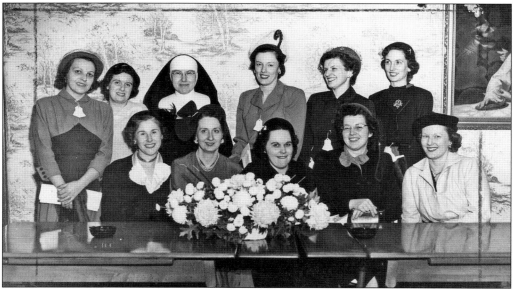

Members of the class of 1940 are pictured here at their 10-year class reunion in October 1950. Their class moderator, Sister Elvira Bredel (third from left, back row), joins then. Sister Elvira was a librarian at the college until 1953 when she became the school's third president, a position she held until 1962.

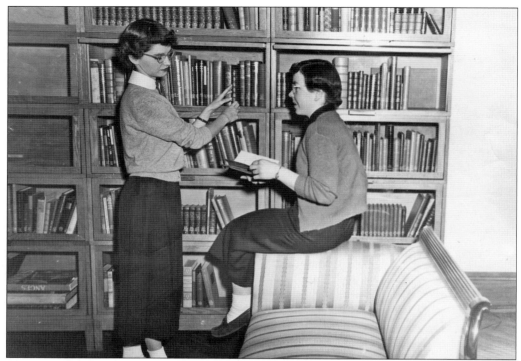

Students Jeanne Sweeney ('54) and Dorothy Feuerborn ('55) look through books in the old Raymond Room. John L. Raymond was a generous benefactor of the CSF Library, donating approximately 1,600 books between 1950 and 1974. In 1952, a separate room in the old library located in the Motherhouse was created to house the books and other artifacts he donated, including the couch in this photograph.

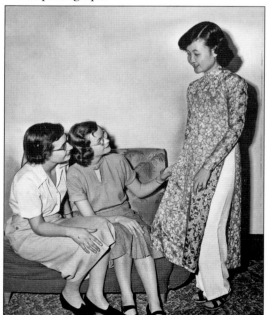

Originally the majority of CSF students were young women from the Joliet area, but that quickly changed. Enrollment expanded further when, in the late 1940s, a scholarship program was developed for foreign students, enabling girls from China, Korea, Vietnam, and South and Central America to study at CSF. In this 1953 photograph, Catherine Thanh from Vietnam models native dress for (from left) Carol Anne Archibald ('55) and Virginia Cronin ('54).

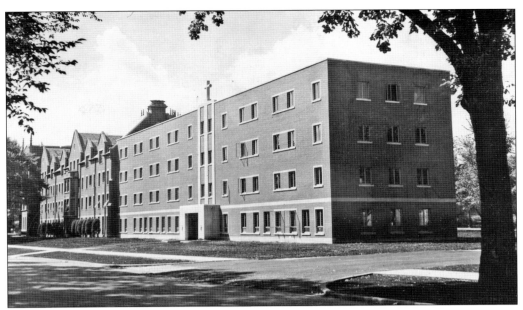

Remodeling and reallocation of space within Tower Hall and the Motherhouse began to fail to meet the ever-growing needs of the sisters and students on campus. An addition to the Motherhouse was built in 1953, creating a third wing called the Novitiate to house the growing number of young women who were entering the congregation. In 1955, quickly following this expansion, Tower Hall was extended eastward along Taylor Street to provide residence space for the sisters who were faculty at CSF. The small St. Joseph's Cottage was torn down to make room for the addition to Tower Hall, ending its years of service as a home for many. The photographs on this page show the new residence wing from two perspectives.

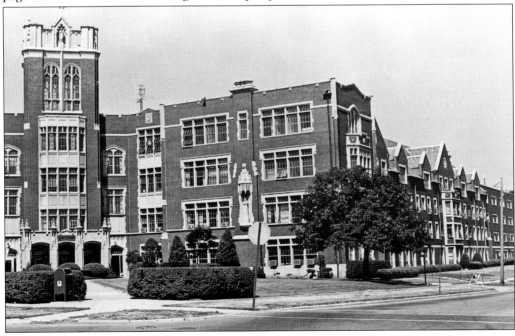

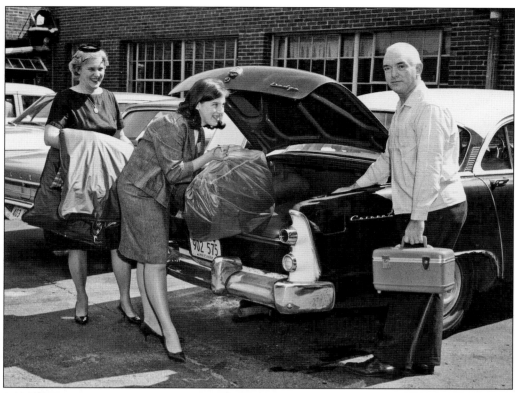

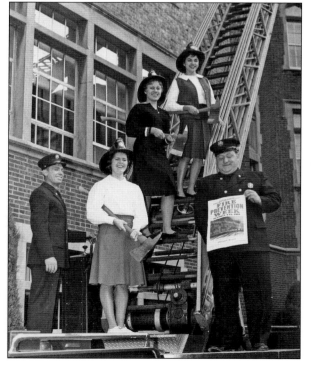

The new residence wing of Tower Hall freed more space for students at CSF. Sophomore Susan Wall ('68) helps her parents unload the car in 1965. Their attire was quite different than what one would expect to see on a move-in day today, and the fact that they were able to transport everything in a car instead of the U-Haul trucks used today shows how different dorm life was in the 1960s.

A few short years after the new residential wing of Tower Hall was completed in 1955, the school promoted Fire Prevention Week, October 9–15, 1960. With more students living on campus, there was also a need for more safety education; here, three freshmen pose on a fire truck with members of the Joliet Fire Department.

As the years progressed and the college grew, education remained the top priority for the sisters. Cooperation was at the front of these sisters' minds as they met to look over slides and discuss programs. From left to right are Sister Rita Greene, art department; Sister Carolette Grote, children's theater; and Sister Rosaire Schlueb, music department.

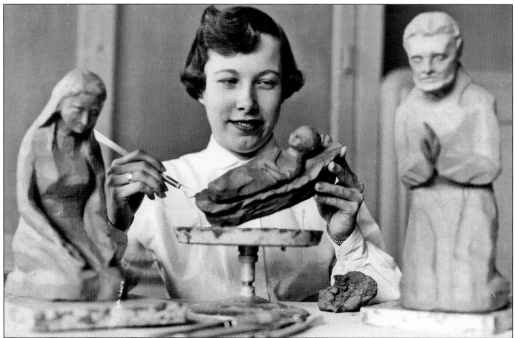

Art became an official major in 1944 but had been an integral part of the life of the sisters since they were founded in 1865. Their talents and devotion to art helped create an open learning environment for students taking art classes at CSF. Pictured here is student Carol Pubentz ('56) working on her sculpture of the baby Jesus to add to the finished Mary and Joseph.

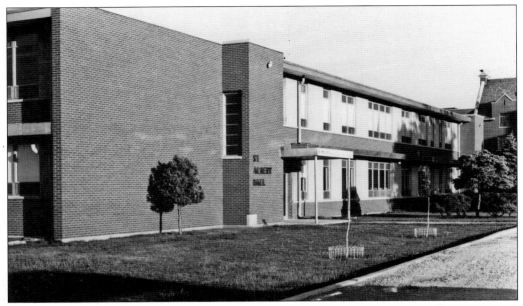

Sister Joan Preising was a chemist and faculty member at CSF from 1939 to 1969. She made it her personal mission to raise enough money to build a separate science building on campus. By writing a book, gathering grant funding, and receiving contributions from the Caritas Dinner, St. Albert Hall became reality with the ground-breaking held in April 1959; classes were held in the new science building beginning in 1960.

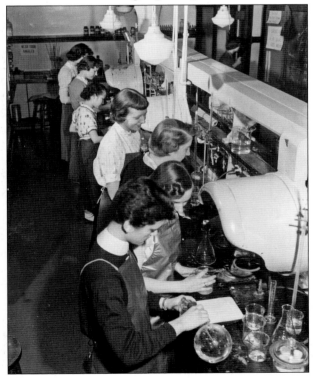

The new St. Albert Hall science building moved the laboratories out of the basement and into a light, airy building. This photograph shows students in one of the chemistry labs. They are wearing the necessary aprons, but despite the sign posted on the wall in the top left corner, they have neglected the goggle portion of the required lab uniform.

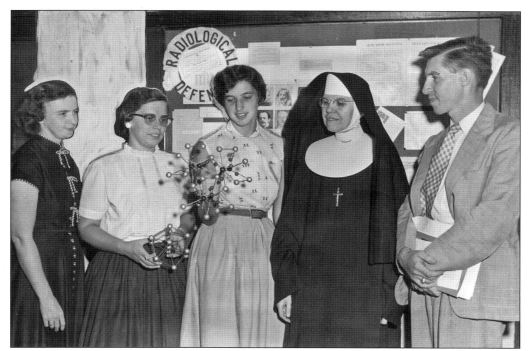

In 1956, CSF was appointed as one of 25 centers in the state where teachers could obtain information and training for handling problems in the event of a nuclear disaster. Over 125 people attended the Radiological Defense Training Program sessions, including, from left to right, Anne Bannon ('50), biologist; Mary Ann Hasse ('55) and Gerry Avsec ('56), teachers; Sister M. Borromeo, SFA principal; and Dr. Charles F. Ehret, associate biologist.

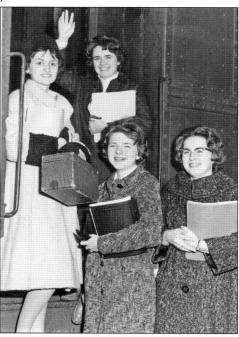

In 1959, with the addition of the new science building, St. Albert Hall, the science programs at CSF blossomed. In 1963, chemistry students, from left to right, Mary Lou Shonka, Jean Latz ('65), Betty Louis, and Joanne Gaworski ('65) travelled to Ames, Iowa, to spend a weekend doing enzyme research at Iowa State University under the direction of two members of the biochemistry department at ISU.

Sister Anita Marie Jochem became the fourth president of the College of St. Francis in 1962. She was appointed just as years of planning and preparation came to fruition with the incorporation of CSF on October 22, 1962. She was the only sister to serve as president after the administration of the college and the congregation legally separated and was an excellent leader during the building era that followed.

In 1958, Sister Elvira Bredel and her board of advisory began the Caritas dinner celebration, a formal event held annually to raise funds for the school. Locations for the event have varied over the years, although it has most recently been held in the transformed recreation center. Students, like these enjoying a sunny afternoon in the quad, were chosen to serve as hostesses at the annual event.

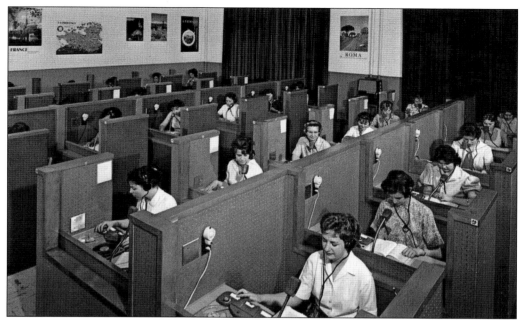

Language was an important part of course work for students at the College of St. Francis. In 1956, the college opened the large language laboratory seen in the postcard above. The room had 29 separate booths with each containing a tape recorder, microphone, and headset. The lab had four separate channels allowing for the study of French, German, Spanish, and Latin. Students could tune in to the appropriate channel and use the provided equipment to listen, speak, record, or playback depending on their need. In the photograph below, students work at the main control station setting up the tapes and records to play over the channels.

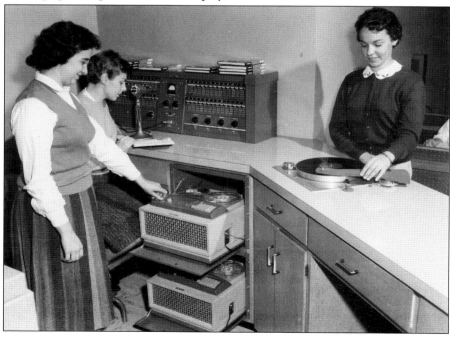

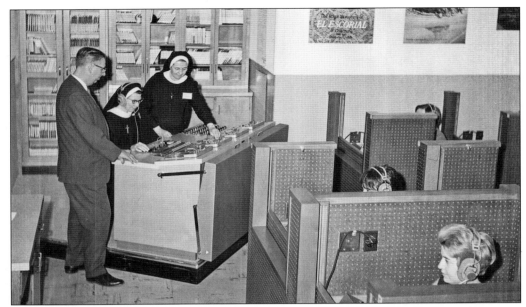

In 1966, the language laboratory was expanded with funding from the National Defense Education Act's grants for language laboratories and with a $14,000 grant from the Raskob Foundation. This photograph shows, from left to right, Fred Haake, an engineer; Sister M. Francine Zeller, chairman of romance languages at CSF; and Sister M. Protase Novak, laboratory director, testing the new equipment.

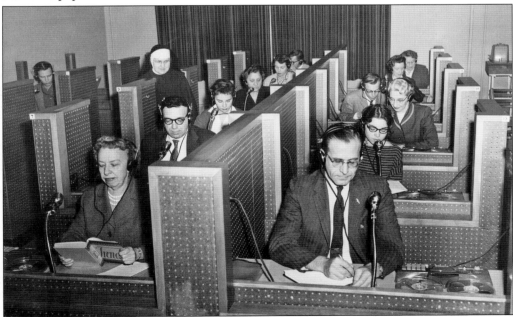

The CSF Language Lab was a success, and use of the lab was expanded to include adult students and possibly people from the surrounding community. The language lab users in this photograph are overseen by Sister Aniceta Guyette (standing), who, in addition to being the second president of CSF, was also a French instructor for many years.

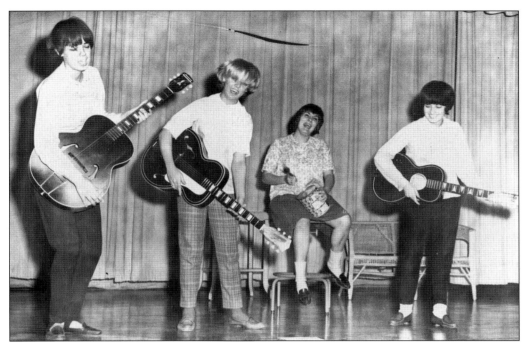

The 1960s were a magical time for rock music, and the College of St. Francis was not immune. The wearing of uniforms ended around 1964, allowing the students more freedom of expression during the class day. This change fed right in to the music and social revolutions of the time. The students in this photograph seem to be imitating one of the 1960s biggest bands, The Beatles, in a talent-show performance.

The CSF Alumnae Association held an annual CSFans program, usually in the spring, to welcome the graduating class into the association, to recognize campaign workers, and to take time to socialize with other alums. Joan Meinsen ('50), at left, was chairman of the 1964 CSFans annual program, and in this photograph she is seen speaking with class president Mary Ann Meyer ('64) at the meeting held on April 16.

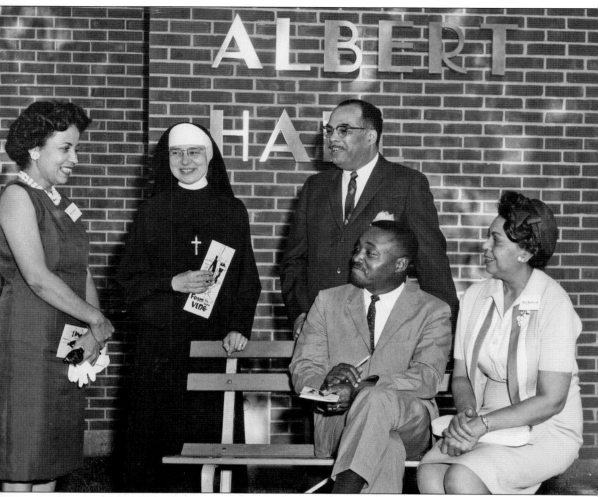

The Sisters' Interracial Day, or Civil Rights Day, was held at CSF on June 24, 1964. In 1964, the United States was in the midst of the civil rights movement, and while prominent leaders like Martin Luther King Jr. were making great strides, the Student Nonviolent Coordinating Committee (SNCC), led by college students, was also making a mark in the country with its organized sit-ins and other acts of nonviolent civil disobedience. The theme of the day at CSF was "From the Same Vine" and was organized by the sisters in an effort to create more open communication and awareness between different races. Topics of the day included Religion, Race, and Revolution; Understanding the Interracial Question; Civil Rights and Human Dignity; and Youth Education and Interracial Justice. This photograph shows Sister Euthelia Schlesser, event organizer, with several small group discussion leaders (from left to right) Mrs. William H. Wilson, Joseph Matthews, Charles Cain, and Mrs. Matthews.

The 1962 incorporation of CSF allowed the school access to state and federal grants. With these new funding sources available, the college began an ambitious building program, spearheaded by the president, Sister Anita Marie Jochem. The building era had begun with St. Albert Hall in 1959 but picked up speed in the 1960s with the plans for an auditorium, a residence hall (Marian Hall, above), and a library.

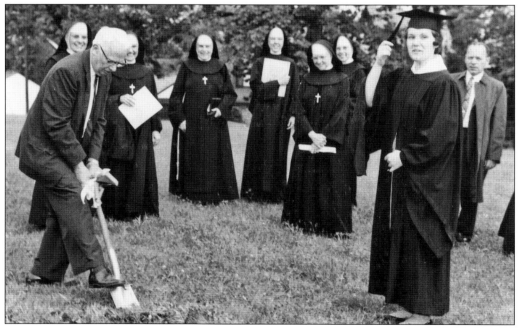

The ground-breaking ceremony for Marian Hall, the new residence hall, was held in 1965. History professor Dr. Frank Weberg (with shovel) was one of those asked to participate in the festivities, while sisters (from left to right) Anita Marie Jochem (president), Tharla Meara, Anacleta Lang, Mary Bartels, Mercia Gillivan, and Janet Kahler watched. Marian Hall was completed in 1966 and added room for approximately 250 more students to live on campus.

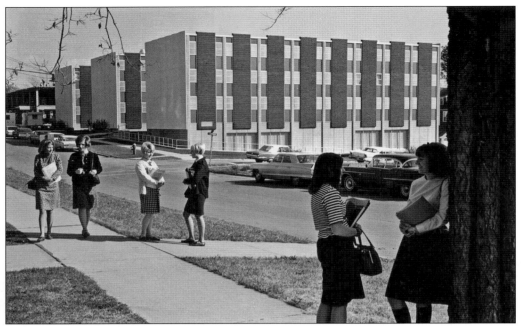

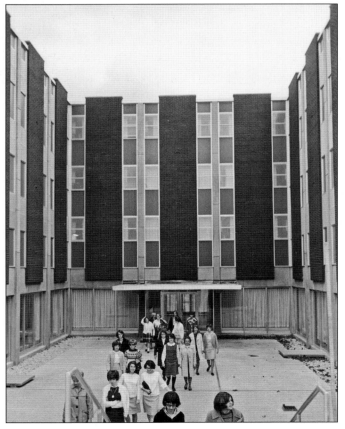

The Sisters of St. Francis donated to the college the land along Taylor Street between Whitney and Dixon Avenues. The sisters had owned this property for many years and used the little cottage located on it, called St. Clare's, as both residence and classroom space. The college used this land to move forward with its plans to build a new residence hall and separate library. Marian Hall (above) is an E-shaped residence hall located on the corner of Taylor Street and Whitney Avenue. It was first used in 1966 and created space for approximately 250 more residents to live on campus. It was built on land that was not completely flat, which made for the unusual architectural feature of the main entryway being below ground level (left).

The overcrowded conditions of the library in the Motherhouse could have cost CSF its accreditation with the North Central Association. As a part of the building program, an extensive new library was erected on Taylor Street across from the Motherhouse. Built in 1967 by the architects Semitekol, Larson, and Stromsland, it cost $1,009,606 and could house up to 200,000 volumes compared to the old library's 57,000 volumes. It was completely air-conditioned with recessed windows and a lobby of verte jade renaissance marble. The last part of the building program was a proposed auditorium or fine arts building that would be built at the north end of Tower Hall. These plans were postponed and finally abandoned. It was decided that the school would continue to use the multipurpose auditorium in Tower Hall, although hopes for a new and distinct fine arts building remained.

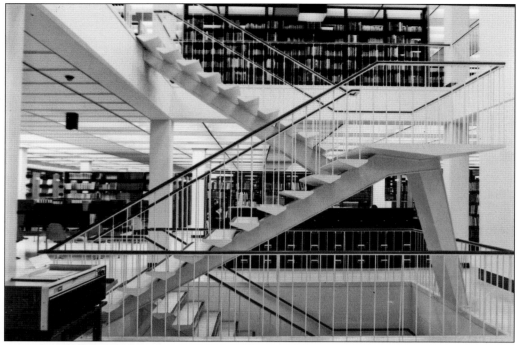

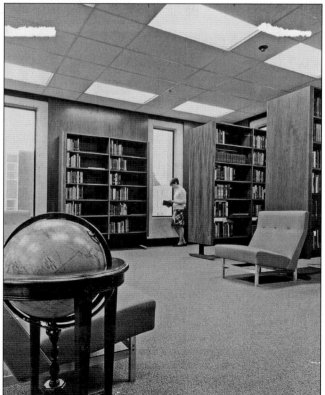

The new library included a floating staircase in the center of the building that gave access to all three floors. The first and second floors included most of the circulating and reference materials, while the ground floor was mainly reading and studying areas. The only classroom space was on the ground floor and was reserved for classes in the library science program.

The second floor of the library included separate spaces for the John L. Raymond Room, the rare book collection, and the CSF Archives. In this photograph, a student looks through the books in the John L. Raymond Room, which was a separate collection both in the old library and the new. The rare book room held over 150 rare books with various languages represented and a group of miniatures.

Four

MEN?
1970–1990

The beginning of the 1970s brought huge change to the College of St. Francis. In 1969, the school appointed the first lay president, Dr. Francis Kerins. He took up the work that had already begun between CSF and Lewis College (now Lewis University) to create plans to merge the two schools. The schools tentatively merged for one academic year but ultimately remained two separate institutions. After dissolution of the merger, CSF became a coeducational institution for the first time; the new library and Marian Residence Hall allowed enough space for the school to open its doors to men.

With the change to coeducational status, the college recognized the need to expand its athletics program. A full-time athletic director, Elmer Bell, was hired in 1972, and the program was expanded to include varsity sports along with the intramural sports. The CSF Falcons became the CSF Fighting Saints in 1975, and the programs grew from there. In 1986, a new recreation center was constructed on campus adjacent to St. Albert Hall to provide an on-campus space to train and compete.

The school's academic programs continued to grow as well. In 1972, CSF began offering off-campus degree programs; in 1979, they added three new majors to the curriculum, and in 1980 they created the first master's program open to students outside the congregation of the Sisters of St. Francis. By 1990, CSF had almost 30 different majors and minors available to students, as well as three preprofessional programs in dental, medical, and veterinary medicine studies. There were over 20 activities and clubs students could be a part of, including professional clubs, sororities, and honor societies. These changes and additional academic programs were paving the way for the school to eventually obtain university status.

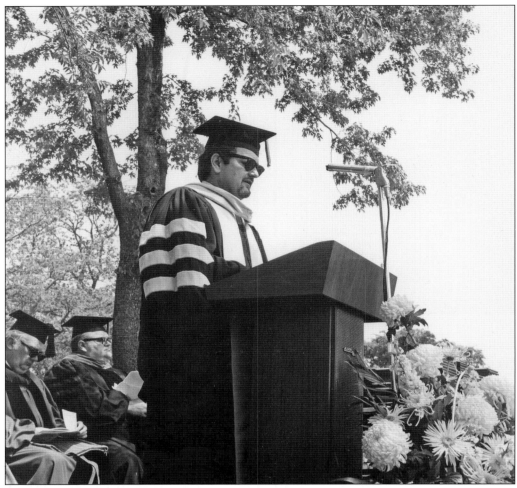

The 1960s witnessed material growth, evidenced in new buildings, and academic growth in the extending curriculum of the college. As the 1970s approached, the school faced more challenges and changes. In 1969, Dr. Francis Kerins became the fifth president of the College of St. Francis and the first lay president. His tenure at CSF was the shortest of any president so far but was arguably the most dynamic. President Kerins and other administrators at CSF began to meet with Brother Paul French, FSC, president of Lewis College (now Lewis University) and other Lewis officials to discuss a possible merger between the two schools. The merger was ultimately unsuccessful but led to CSF becoming a coeducational institution for the first time in its almost 50-year history. The school was heading in a new direction. Dr. Kerins expressed it well when he wrote, "1971 saw [the] birth of 'new' CSF." This photograph shows Dr. Kerins addressing the crowd at a graduation ceremony during his tenure as president from 1969 to 1974.

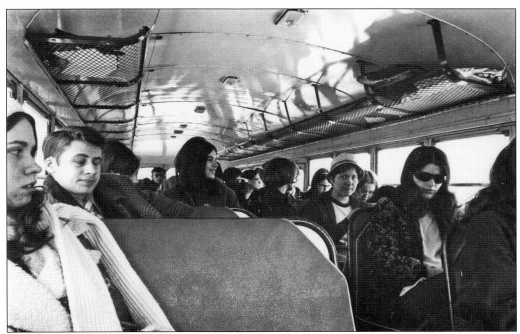

During the 1970–1971 academic year, the College of St. Francis was known as Lewis-St. Francis of Illinois after merging with Lewis College (now Lewis University) of Romeoville, Illinois; the merger allowed students to take classes at both college campuses. A bus service, like the one pictured above, transported students between Lewis (North Campus) and CSF (South Campus) throughout the day. The administrations of the two schools spent a great deal of time and energy working out the details of the merger but ultimately were unable to make it permanent. The two schools dissolved the merger in 1971, but CSF remained a coeducational institution. The photograph at right shows CSF students returning to campus after their bus ride back from Lewis.

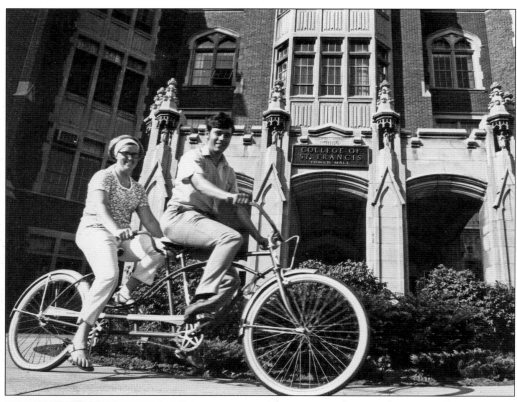

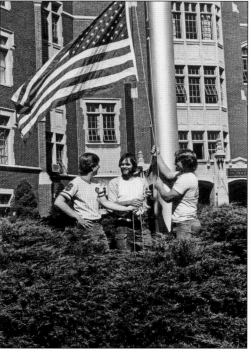

The merger of CSF and Lewis College was unsuccessful but the couple here, riding their tandem bicycle in front of Tower Hall, represents another type of merger between the two schools. Pat (Reavley) Hunnewell graduated from CSF in 1969, while her husband, Bill, graduated from Lewis in 1968.

One of the big program changes that came with the new coeducational status of the college was the establishment of official athletic teams. In 1972, the athletic program was expanded from only intramurals to varsity sports, intramurals, and physical education classes. Here three student-athletes raise the American flag in front of Tower Hall in the fall of 1976.

Taylor Street has long been a hub of activity on the main campus for students and staff alike. On the north side of the street are Tower Hall and the Motherhouse, the venerable buildings housing classrooms, faculty offices, administrative offices, dorm rooms, and the cafeteria. On the south side of the street are the library and Marian Hall, built in the 1960s to accommodate the growing population on campus.

The alumni of CSF have a long history of supporting the school. They respond favorably to requests to lecture at the school, to recruit, and to keep in touch with classmates. The 1972 Phonathon was a great success. Led by Joann Placher ('60), director of development and alumni affairs (standing), the volunteers spent 13 nights calling CSF alumni across the country and received pledges from 83 percent of those contacted.

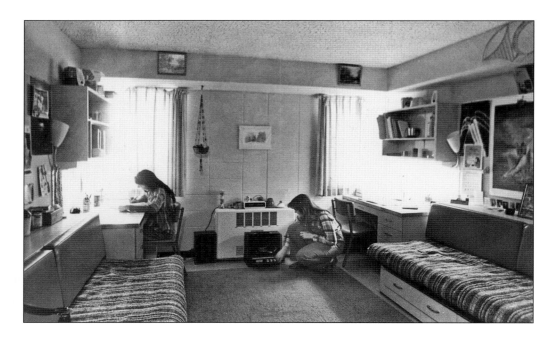

The new Marian Residence Hall provided more space for students on campus. Along with creating rooms for approximately 250 more student residents, the building also contained a game room, theater complex, and study space. The rooms came furnished with pullout sofa beds, desks, and bookcases mounted to the wall. There were limited ways to arrange the furniture, but like in today's dorm rooms, students were able to decorate and make it their home away from home. Above, two roommates use their room as a study space while listening to their record player; below, three students relax, looking through their LP's during a game of chess.

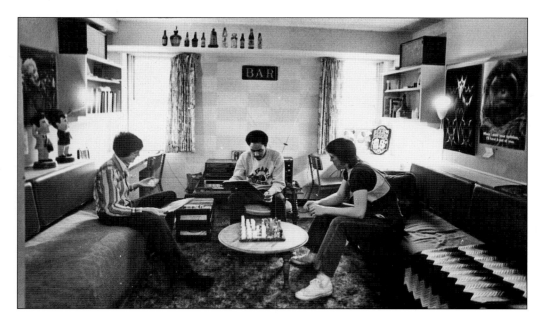

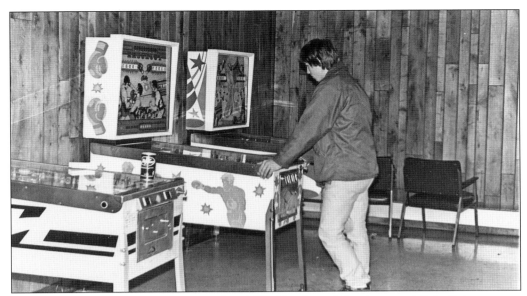

The Marian Hall lounge was renovated in 1976. The formal furniture and light fixtures were removed and vending machines, table games, and arcade games were brought in. Students, like the one pictured here playing a pinball machine, were able to use the more casual space for entertainment and relaxing during their spare time.

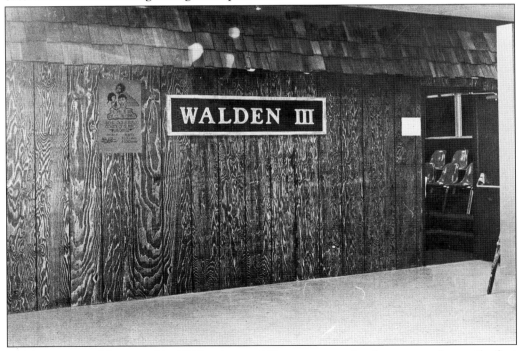

Walden III Assembly opened in 1977 and was a 140-person capacity theater complex on the first floor of the east wing of Marian Hall. The addition of the new space was a much-needed asset, and despite the fact that it took two years to complete, the theater program at CSF thrived using the theater throughout construction and for many years after.

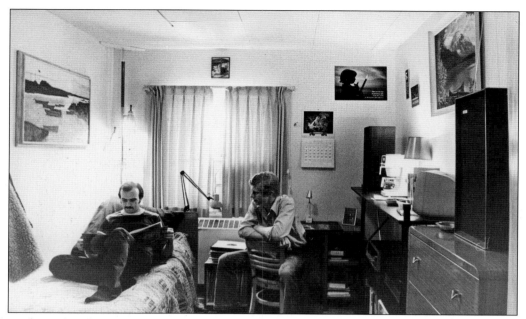

By the 1970s, the rooms in Tower Hall's residence wing were all used by students. Like in the early days of the college, the rooms had more than one configuration but were generally limited to single or double rooms. In this photograph, a student visits a classmate in his single room.

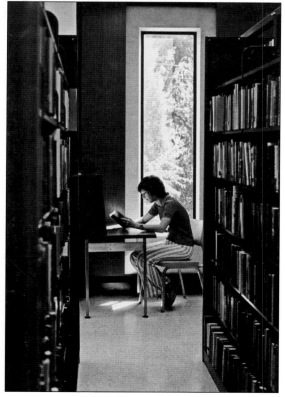

In 1976, the CSF Library was awarded a grant for $8,000 from the W. K. Kellogg Foundation for the purchase of computer terminal equipment. This early computer was the first to be installed in the library and was linked to the Library of Congress so that information could be retrieved quickly and used by the technical services staff to speed up the cataloging process.

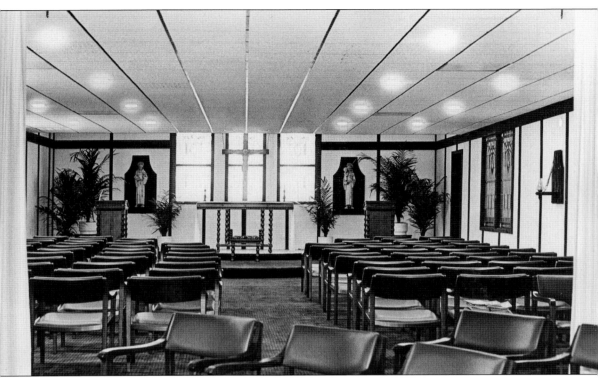

In honor of the late Sister Anita Marie Jochem, former president of CSF, two newly renovated chapels were dedicated in June 1976. There had originally been a single chapel, but the renovation divided the room into two, first with a white drape and then with a thicker partition separating each. The main chapel was used for weekend liturgies and occasionally for "dignified and approved celebrations of the fine arts." The smaller chapel housed the Eucharist and hosted the daily mass. To raise funds for the chapel renovation project, the 88 pews from the old chapel were sold to CSF alumni and put to various uses in their new homes. One couple had to overcome a minor obstacle in their eagerness to pick up their newly purchased pew; Mary Ellen (Daly) Gallagher ('71) and her husband, Jim, arrived at CSF and found the chapel doors locked because of the construction. Not able to find anyone to unlock the doors, they simply removed the door's hinges, found the pew marked with their name, removed it, and replaced the door and its hinges.

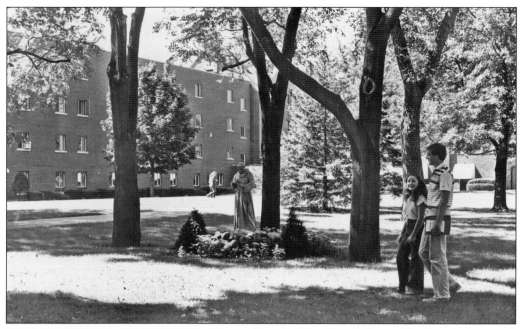

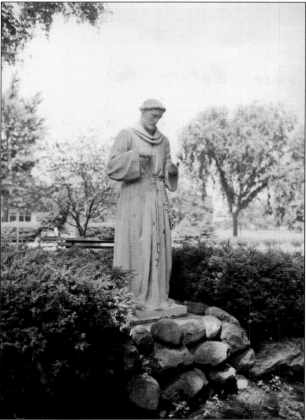

The College of St. Francis is named for Saint Francis of Assisi, the early 13th-century founder of the Franciscans and patron saint of animals. The college's founders, the Sisters of St. Francis of Mary Immaculate, named many of their ministries in his honor, including the St. Francis Academy high school and CSF, whose original name was Assisi Junior College. Saint Francis is represented in artwork all over campus. The largest statue of Saint Francis was originally given a prominent place in the quad. He sat on a rock platform and was surrounded by the nature that he was said to love in life. He was recently moved to a spot in the front of Tower Hall's portico where he joins the smaller statues that adorn the outside of the upper floors of the building.

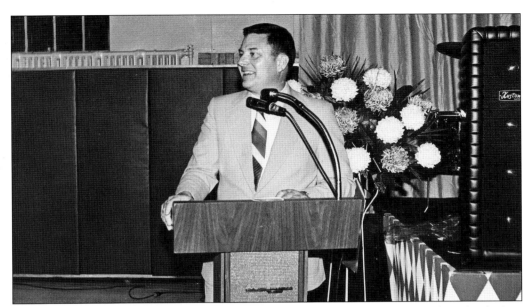

Dr. John C. Orr was named the college's sixth president in 1974. He came to the school when it was still recovering from the dissolution of the merger with Lewis and was trying to find its footing. The school was rapidly growing with new athletic programs and an assortment of new students. President Orr planned to "continue to build on the ideals of St. Francis and the traditions of the college."

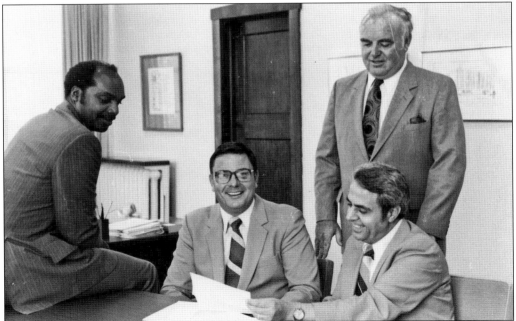

Pres. John C. Orr (center) held the position for the longest of any president so far. He was in office for 21 years, from 1974 to 1995, spending two decades serving and leading at CSF. In this 1982 photograph, he is meeting with CSF trustees (from left to right) Wendell Johnson, John W. D'Arcy, and Al Ruscilli about the college's annual report.

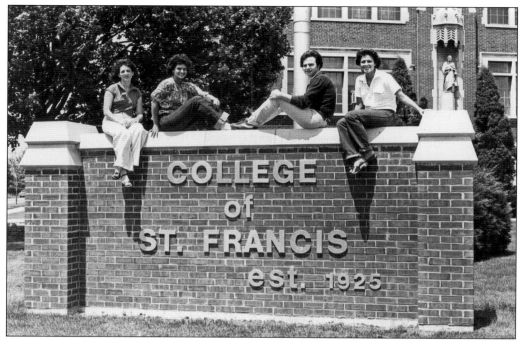

Even as the college's main campus grew, CSF began to expand in other areas. In the fall of 1972, CSF began to offer the first off-campus degree programs starting the nontraditional learning that is still an important part of the school's academic programs today. In this photograph, the Student Government Association officers from 1979–1980 sit on the newly added brick sign on the lawn of Tower Hall.

Uno is a popular card game that was invented in 1971, but it really took off when it was sold to a funeral parlor owner in Joliet who formed International Games Inc. to market the game. The Uno Lounge in Tower Hall is named in grateful recognition of International Games Inc. and the colorful card game the company made famous. In this photograph from 1984, two students work together in the lounge.

Expanded academic departments meant more choices for CSF students. The decision of what to study was sometimes made harder by the myriad of options. The college began holding "fairs" to give students a chance to meet with staff from the different departments to ask questions and gather information. Here an undecided student meets with Tom Kennedy (right), the director of career planning and placement, to learn more about his options.

There were 11 graduates in the class of 1930. Fifty years later, the class of 1980 numbered 1,104. With many more students on campus each day, the need for supplies increased as well. This large supply closet, possibly near the kitchen in Tower Hall, was one of the spaces dedicated to storing the supplies necessary to support the students, faculty, and staff on campus every day.

CSF's collaborations with the local community continued during all the changes that came with the 1970s. In 1976, the education department hosted an afternoon champagne party for teachers and administrators of Joliet area schools. The get-together took place during the college's 50th anniversary year and was an opportunity for the CSF administration and faculty to express their appreciation for the schools' contributions to the CSF student teacher program.

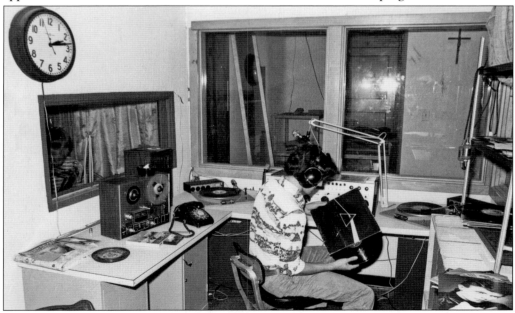

Student radio at USF began in 1945 with the CSF Radio Workshop; broadcasts were prepared by students and aired on local station WJOL. With the formation of the mass communication department in 1976, WCSF was created to educate students in all aspects of running an FM radio station. It originally broadcast only to the dorms, but in 1988 it was licensed by the Federal Communications Commission (FCC) to air on 88.7 FM in the Joliet area.

Some of the projects taken on by students at CSF were outside the traditional classroom experience. The student pictured is in the therapeutic recreation program, which focuses on ways that recreation can be used in therapy and rehabilitation. He dressed as a clown and made balloon animals with children and was thanked with a kiss by one of his young fans.

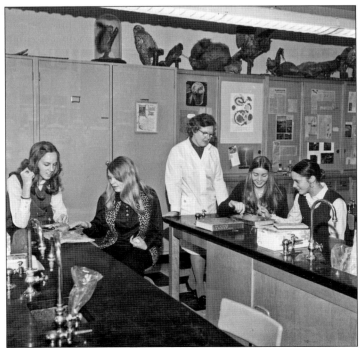

The Kirk Biology Center in Tower Hall was dedicated in March 1980 and is named for Sister M. Vincent Kirk (standing). Sister Vincent's life at CSF included Biology Club organizer, "house mother," health arts program originator, continuing education for RN's program originator, and department chairman, but she is remembered most as professor of biology, a position she held for 41 years.

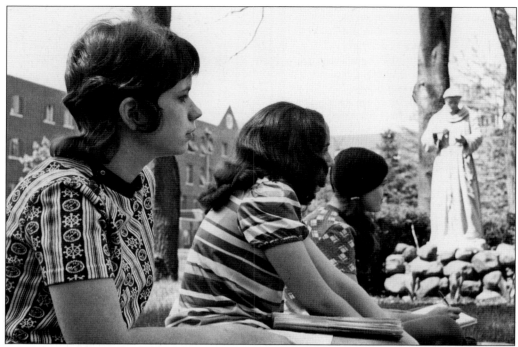

When the student uniform requirement ended around 1964, it began a new era of more relaxed class formats at CSF. Classes started to move from the traditional desks and lecture format to more open environments. Some sat in circles on couches or beanbag chairs, while others, like the students above sitting near the statue of St. Francis of Assisi, moved their classes outside and met on the quad.

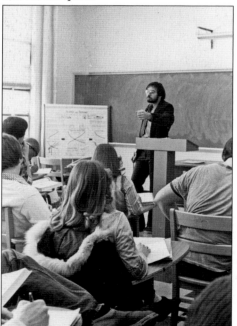

When the college opened in 1925, the Sisters of St. Francis taught all classes, with the exception of physical education, but by 1980 the majority of teachers were lay professors. Prof. Michael LaRocco, of the business department, led this class around 1979. Dr. LaRocco has been teaching at the school for over 27 years and is the dean of the college of business and health administration.

In 1979, three new majors—religious studies, foreign affairs, and creative arts—were added to the curriculum at CSF to bring more order to the growing theology, political science, and art programs. Soon after these new majors were implemented, the school embarked on a new venture, offering a master's level program in health services administration in 1980. Graduate degrees had been offered in the 1960s with the MA in Franciscan Theology for sisters, but this new master's program was open to all. Students in these photographs were undergraduates that now had the opportunity to continue on for their graduate degree at CSF.

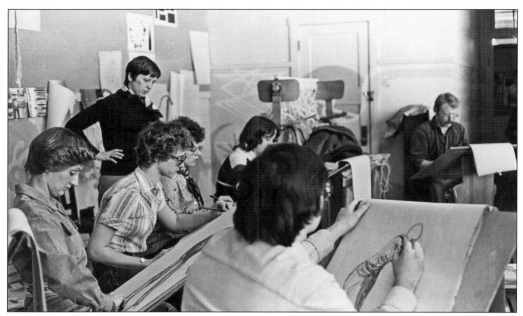

The CSF Alumni Association established Alumni College in 1972. This college ran for several years and allowed alumni to brush up on their education or to keep current on what was being taught in college at the time. The classes were offered in condensed formats of anywhere from one to three evenings. CSF professor Karen Kietzman (standing) taught the alumni college art class that is pictured.

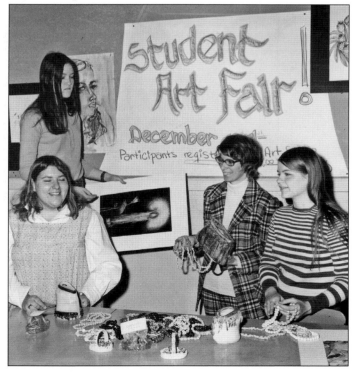

CSF offered an integrated series of lectures, concerts, piano recitals, and theater and dance performances sponsored by the fine arts department, student life, and student government. Students in the creative arts program were given numerous opportunities to learn, practice, and showcase their abilities. These students are preparing items to be shown at the student art fair.

On April 7, 1984, the Delta Kappa chapter of the Delta Mu Delta International Honor Society in Business was chartered at CSF. In this photograph, CSF president Dr. John C. Orr (left) and Michael LaRocco, chairman of the business administration department (right), receive the official certificate for the chapter. This was one of the many academic honor societies that CSF students were able to join in their department.

Almost 15 years after Marian Residence Hall was built, members of the admissions office moved into their new home in a renovated house on the southeast corner of Wilcox and Taylor Streets. The additional on-campus space and the emerging academic programs created more interest in the school, leading to a busier admissions staff. Hanging the sign in 1980 are the admissions staff, including Sheryl (Kocher) Paul ('70, left) and Chuck Beutel (second from left).

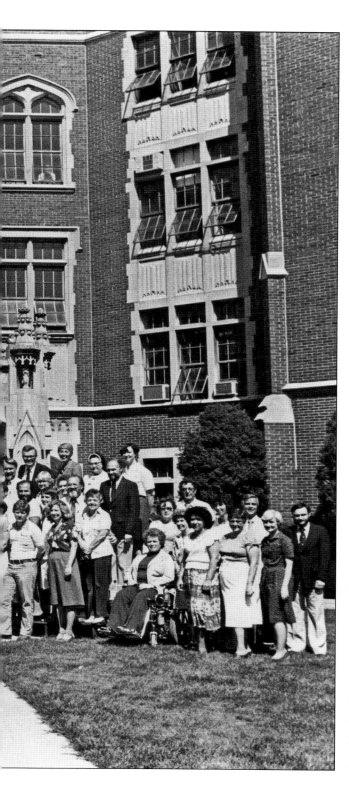

By 1982, the College of St. Francis was making a significant economic contribution to the Joliet-Will County area through numerous interactions with the region's businesses, financial institutions, government, and individuals. According to a study done by James P. McCabe, associate professor at CSF, the college, its employees, students, and related activities generated $18,904,523 of business during the 1982–1983 fiscal year, helping to promote the continued prosperity of the region. This group photograph of faculty and staff, taken around 1981 in front of Tower Hall, shows a portion of the people whose lives at CSF affected the community both directly and indirectly.

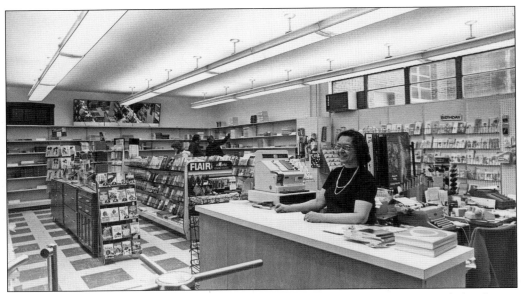

Like every other college and university, the students at the College of St. Francis needed a place to purchase the necessary textbooks and supplies. The CSF Bookshoppe was that place on campus. Located in Tower Hall, it offered supplies like notebooks, pens, and even birthday cards (as seen on the right back wall) in addition to the required textbooks. This photograph shows the store during a slower period.

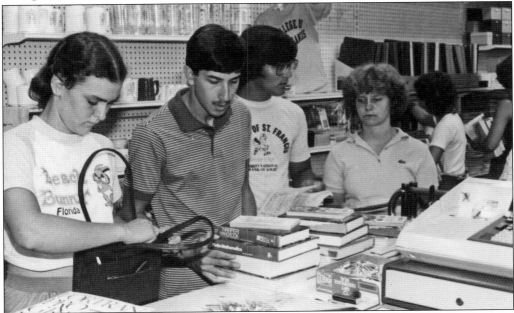

The beginning of the semester was always a busy time at the CSF Bookshoppe. These new freshmen are waiting in line in 1983 to buy their stacks of books for the first time. These students were most likely part of the traditional four-year program at CSF, but the school offered other nontraditional options for studying. There were degree completion programs for registered nurses, evening college programs, and a three-year program.

The three-year program at CSF ran from about 1972 to 1982. It allowed students to meet their general education requirements by taking five multidisciplinary courses, which included many areas of study. These classes, along with their program of major study, provided a complete education in six regular semesters. These students, looking through textbooks in the CSF Bookshoppe around 1976, would have had the opportunity to study in this program.

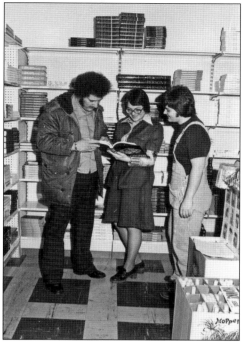

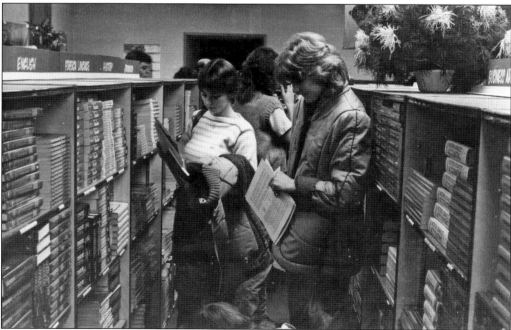

In 1984, the college opened the new CSF Bookshoppe in its current location. The new location allowed the bookstore to separate the textbooks from the other merchandise, giving both more space. In 1984, these students are shopping for their textbooks in the new area. CSF also expanded its offerings of CSF merchandise, publishing a catalog that featured various types of CSF apparel, mugs, and pens.

From the early days, the two congregations of Franciscan Sisters exchanged their services of education at the College of St. Francis with medical care at St. Joseph Hospital. This arrangement continued for years and only ended when the hospital and nursing school moved to the location between Jefferson Street and Glenwood Avenue in 1964.

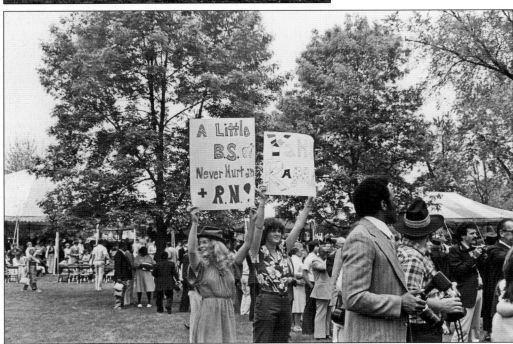

In 1987, following an extensive needs assessment, the Saint Joseph School of Nursing decided to become an upper division college. The school changed its name to the Saint Joseph College of Nursing and began awarding the Bachelor of Science in nursing degree. This change later led them to become a division of the University of St. Francis with the new name College of Nursing and Allied Health.

The Illinois Department of Human Services' Division of Rehabilitation Services (DORS) serves individuals with disabilities, partnering with them to help them achieve full community participation. Sister Rosemary Small (seated right) worked to improve conditions on campus in order to make the school more accessible. In 1980, she, along with Pres. John C. Orr (standing right), accepted a plaque from the staff of DORS in recognition of their efforts.

The Student Government Association (SGA) had a presence on campus since the early days of the college. Originally all students enrolled belonged to the organization, although not all were active members. During the 1979–1980 academic year, the SGA was led by (from left to right) Clare O'Neill ('80), Therese DeSerto ('81), Paul Lockwood ('81), and Joan Salzman and together, with other SGA members, coordinated and funded student organizations, clubs, and activities.

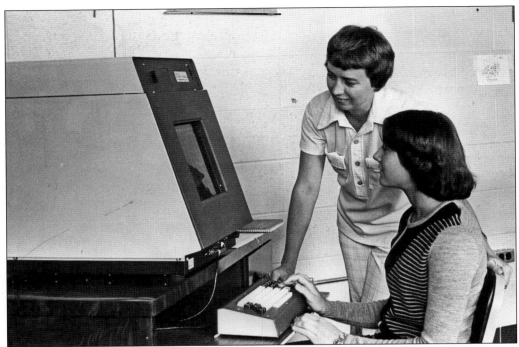

The PLATO V system was introduced in the fall semester of the 1977–1978 academic year. The Programmed Logic for Automatic Teaching Operations (PLATO) was an individualized system of computer-assisted instruction that allowed students to set their own pace while progressing through lessons. The PLATO computers belonged to the mathematics department but had sessions on a variety of subjects. Sister Lourdes Boyer (standing in the photographs) was the director of PLATO and an instructor in mathematics and computer science at CSF. In the photograph above, she is overseeing Kathy Kozar as she works through a lesson, and in the photograph below, she is helping Karen Kon solve a problem.

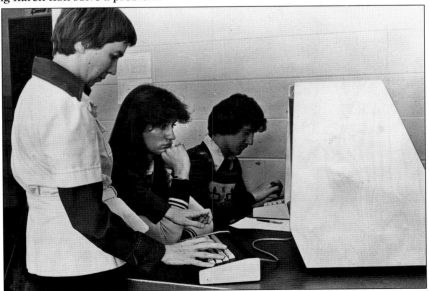

In 1972, under the direction of athletic director Elmer Bell, the athletic program at CSF was expanded, and varsity athletic teams were formed. The programs really began to take off with the hiring of Gordon "Gordie" Gillespie (seen here) in 1976; he became the school's second athletic director and in addition has coached baseball, football, and women's basketball during his illustrious career at CSF.

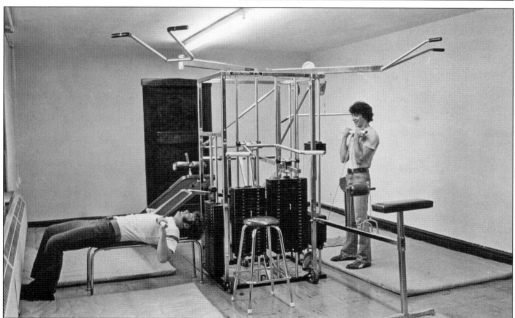

When the athletic programs were just beginning, the school's facilities were less than ideal. Many sporting events and practices had to take place off campus in areas around Joliet. In 1975, CSF purchased a Universal weight machine, being used here by students Larry Wysocki ('79) and Mike Streit (right), to create the first weight room on campus.

Gordie's Run was a 10-kilometer fund-raising run named for Gordon "Gordie" Gillespie, CSF men's athletic director. An annual event in the early 1980s, it was originally intended to raise funds for the CSF athletic programs but was opened up to other educational groups in the Joliet area. Runners ranged in age from middle school to middle-aged. Coach Gillespie said the race "can point out to the community the dedication and commitment a student has for his love, sports or band, and the important contributions these programs make to the education of the whole person." In the photograph at left, coach Gillespie is addressing the crowds at the 1983 race, and the photograph below shows racers at the beginning of the 1984 event.

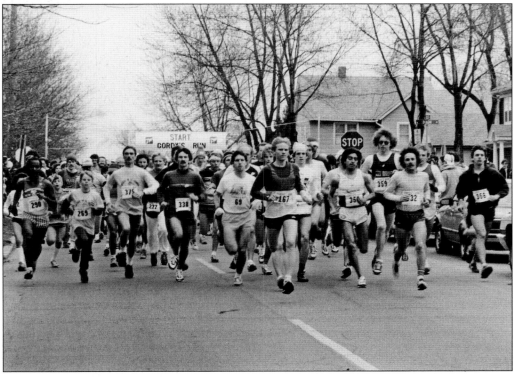

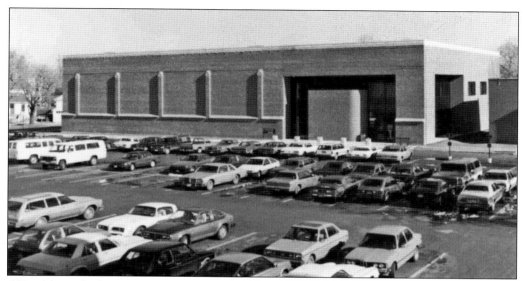

CSF athletics had grown from three programs for men to six programs for men and five for women, as well as 80 percent of the resident students participating in intramural programs. The obvious demand for athletic programs led to the construction of the recreation center in 1986. The three-level facility adjacent to St. Albert Hall allowed CSF to bring many of the sports events back to campus.

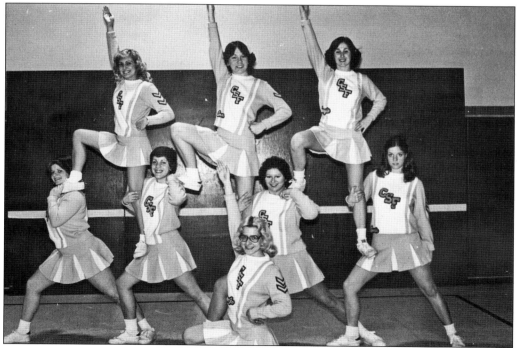

CSF Spiritline began with seven cheerleaders in 1976. Those seven girls cheered for the men's basketball team as well as participated in fund-raisers. The girls pictured are from the 1980–1981 squad. Spiritline became a dance/cheer team in 1988, and in addition to cheering for the CSF sports teams, it began competing as a part of the National Cheerleaders Association (NCA).

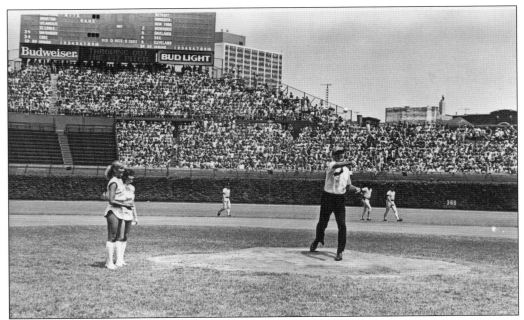

In the mid-1980s, CSF began efforts to raise funds for a baseball stadium. Gillespie Stadium Day was June 22, 1984, at the Chicago Cubs' Wrigley Field and was a fund-raising opportunity for the school. In this photograph, coach Gillespie throws out the first pitch at the stadium. Although the plans for a separate stadium were unsuccessful, the efforts of Coach Gillespie and others raised awareness of CSF and the baseball team.

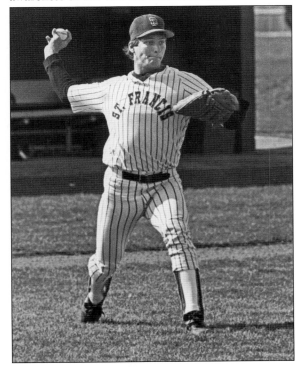

The CSF baseball team reached the 1989 NAIA World Series and was led by pitchers Steve Parris (pictured) and Don Peters. Although the Saints lost in the final game, they had an excellent season and much to be proud of. Parris signed a professional contract following his junior season. He pitched for eight seasons in the major leagues before arm injuries ended his career in 2003. (Courtesy of USF Athletics.)

Women's sports at CSF were making a distinct mark, led by Chris Prieboy ('83). Chris excelled in three sports at CSF—basketball, softball and tennis—leading to her future nickname as the "Michael Jordan" of CSF. Her basketball number was retired in 1983 after she set the career point mark with 2,377 points, and she holds career and single-season records in both basketball and softball that have yet to be broken. (Courtesy of USF Athletics.)

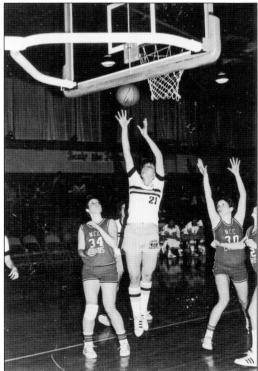

The CSF women's athletics program continued to grow with students participating in varsity basketball, cross-country, softball, tennis, and volleyball. In addition, more women joined the athletic department staff. Mary Ellen Senffner ('77) became the sports information director in 1978, and E. Ann Hope joined the staff in 1979 as women's athletic director. This photograph from the 1979–1980 season shows the women's basketball team in action against North Central College.

CSF's track and field program began with a marathon team in 1972. This unique team had a cross-country season in the fall and a marathon season from December to June. It became the less-official CSF Running Club in 1976, which eventually grew to the track and field teams of the school today. Stephen Meehan ('80) wears his St. Francis Striders shirt while running in front of Tower Hall.

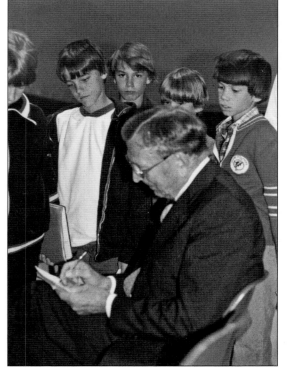

The CSF athletic department recognized that expanding sports programs meant expanding needs for funding. The Brown and Gold Night began in 1977 as an annual fund-raising banquet featuring a guest speaker or speakers from the sports world. One of the biggest names ever to speak at the dinner was UCLA's legendary hall of fame basketball coach John Wooden, pictured here signing autographs for young fans at the 1978 event. (Courtesy of USF Athletics.)

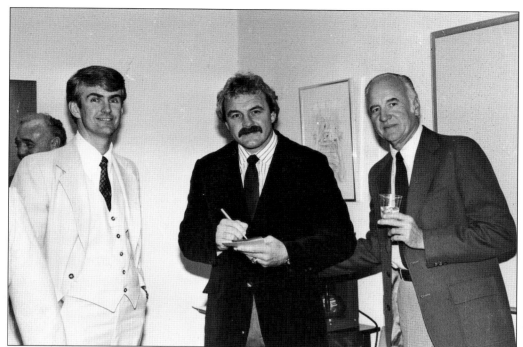

Led by the CSF Booster Club, the Brown and Gold Night is a major fund-raiser for CSF athletics. The annual banquet continues to be a popular event, fostering school spirit and enthusiasm for the school's athletic teams while also drawing attention for the big names that have been featured speakers. In 1980, former Chicago Bears great and Hall of Famer Dick Butkus (above, center) came to CSF to speak at the event. He is pictured with CSF coaching legends Pat Sullivan (left) and Gordon "Gordie" Gillespie. Mike Ditka (right, on the right) was the featured speaker at the 1982 night during his first season as the Chicago Bear's head coach. He later returned to speak again at the event in 2007. (Both courtesy of USF Athletics.)

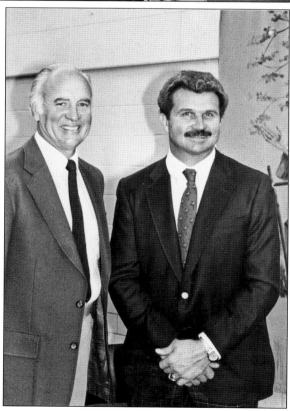

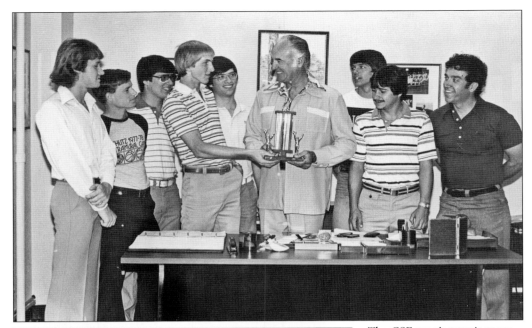

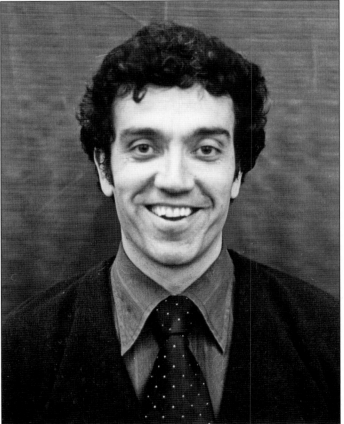

The CSF men's tennis team made its debut in the spring season of 1977 under the direction of Lyle Hicks. Coach Hicks (at left), a longtime faculty member and recreation department head, said, "It'll be a year of learning and gaining experience for us. Our aim is to lay a solid foundation for the future." That solid foundation led to early success with the team winning the NAIA District 20 Championship tournament for two straight years in 1978 and 1979. In the photograph above, members of the team, with their coach (far right), accept a trophy from athletic director Gordon "Gordie" Gillespie. (At left, courtesy of USF Athletics.)

The men's basketball team was one of the first athletic programs established at CSF. For the first year, the team was known as the Falcons and was coached by Bob Penosky. In 1976, Pat Sullivan was hired to coach the newly renamed Saints. Coach Sullivan (kneeling) held many roles at CSF in addition to his 34 years as men's basketball coach and has been honored numerous times.

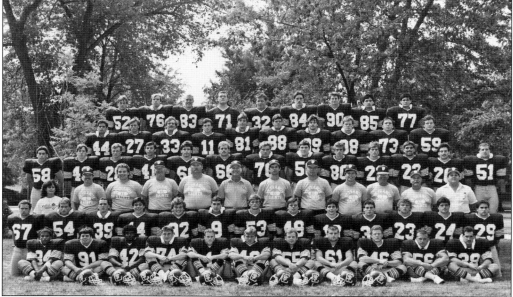

In 1986, Gordon "Gordie" Gillespie began a football program at CSF. Coach Gillespie was already the baseball coach and athletic director at CSF, and in order to take on the gridiron sport, he handed the athletic director reigns to coach Pat Sullivan and became athletic chairman. The Saints posted a winning record of 6-4 in their very first season under the direction of the versatile coach Gillespie. (Courtesy of USF Athletics.)

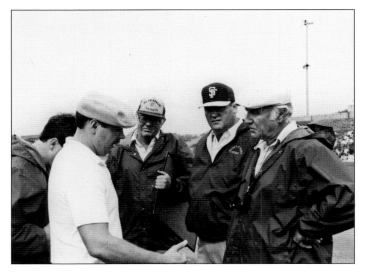

Gordon "Gordie" Gillespie (right) has coached four different sports at four different schools during his career. At least 60 of his players have gone on to sign professional contracts, and his assistant coaches and staff have achieved much over the years. In this photograph, he discusses strategy with offensive coach Dan Sharp (left, in white). Sharp went on to record-breaking success as the head football coach at Joliet Catholic Academy. (Courtesy of USF Athletics.)

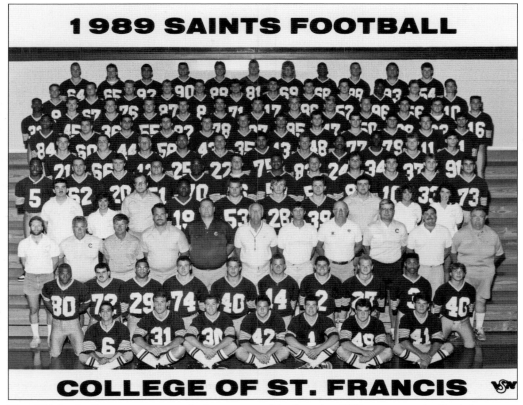

The CSF football program was only three years old when the 1989 team won its final six games to finish with an 8-2 regular season. The Saints were not selected to play in the NAIA postseason playoffs that year, but the .800 winning percentage they earned still stands as the highest in the football program's history. (Courtesy of USF Athletics.)

Five

THE TRADITION

CONTINUES

1990 TO THE PRESENT

The last two decades have seen even more growth and expansion at the College of St. Francis. In 1995, Dr. James A. Doppke became the seventh president and led the way towards university status. In 1997, the board of trustees approved the decision, and university status became official on January 1, 1998. The change was not in name only, as the academic programs were expanded and updated to fit in the new structure. In 2005, the campus renovation program completed a needed upgrade and update of Marian Hall and numerous improvements on the 13-plus-acre campus. The Motherhouse, now more than 120 years old, became needed residence space for the continuously growing student population.

Technology began to change dramatically in the 1990s with personal computers and Internet access becoming commonplace. The university worked hard to keep up with the changes, adding computer labs on campus and expanding the computer science programs. USF is still working to continue innovations in order to create a current and relevant learning environment for all types of students.

By the 1990s, the athletic programs had a firm foothold with many teams reaching championship status both locally and nationally. The addition of the recreation center on campus in 1986 allowed the programs to grow, and USF athletics currently boasts eight men's programs (baseball, basketball, cross-country, football, golf, soccer, tennis, and track and field) and nine women's programs (basketball, cross-country, golf, soccer, softball, Spiritline, tennis, track and field, and volleyball).

More than 200 Joliet Franciscan Sisters have served in every capacity throughout the years of Assisi Junior College, the College of St. Francis, and now the University of St. Francis. USF, as a sponsored institution with its separate incorporation, continues to maintain a close relationship with the founding sisters who are vital members of the board of trustees and the USF community. The university looks to the future now with enthusiasm and optimism, knowing that the next 90 years will be just as full of momentous occasions as the first 90 have been.

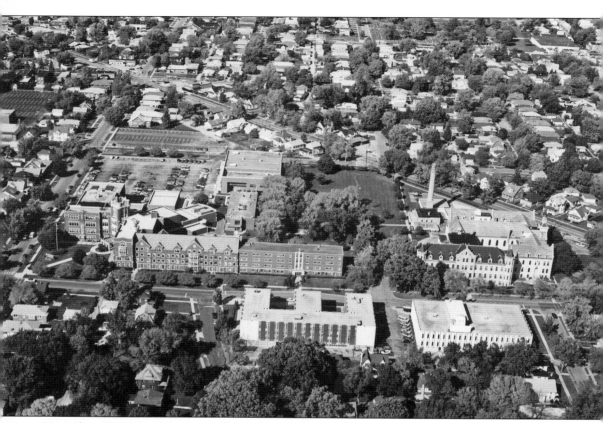

More than 200 Joliet Franciscan Sisters have served at the University of St. Francis. This 1993 aerial photograph shows some of the fruits of their labors. The campus is an attractive blend of traditional and modern located in a residential area of Joliet. The gothic-style Tower Hall (left) is the center of most academic and administrative activities, as well as housing a residential wing. The Moser Performing Arts Center, located in the space behind Tower Hall, was just completed when this photograph was taken. St. Albert Hall and the Recreation Center are both located on the quad. St. Albert serves as more classroom and laboratory space with an emphasis on sciences, while the recreation center is the home of the school's athletic and intramural programs. On Taylor Street, Marian Hall (lower left) is the newer residence area that also includes a studio theater and game room. The library (lower right) has a comprehensive collection of materials to support learning. The Motherhouse (upper right) is the original building on campus but in 1993 was not used by the college.

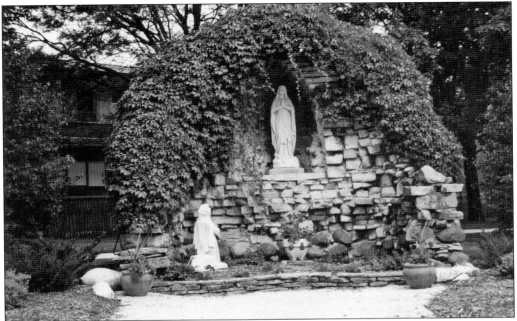

Though it has changed slightly over time, the Grotto of Our Lady Lourdes in the quad continues to be a fixture on campus. This photograph from the 1990s shows the care given to the surrounding landscape as well as the addition of a statue of Saint Bernadette set to gaze towards the Virgin Mary.

This statue of Saint Joseph currently stands in the quad on campus. He holds the carpenter square, symbolizing his trade, and as the foster father of Jesus, he is an important person in the lives of the Sisters of St. Francis. The chapel in the Motherhouse was dedicated to St. Joseph in 1893 and has remained in use to this day.

Sportswriters on TV was a Chicago-based sports talk show that ran from 1985 to 2000. Gordon "Gordie" Gillespie (center) was a featured guest on the show in the early 1990s with (from left to right) Bill Gleason, Rick Telander, Ben Bentley, and Bill Jauss. In addition, the *Sportswriters on TV* cast came to Joliet in 1990 to serve as the featured speakers at the annual Brown and Gold Night. (Courtesy of USF Athletics.)

The 1990s produced great accomplishments in the Saints' athletic programs. The CSF baseball team won the NAIA national championship in 1993, and the volleyball team finished fourth at the national tournament in 1990. The men's basketball team qualified for the 1994 and 1996 NAIA Division I Championship tournaments. The team is pictured here during first-round action against Northwestern Oklahoma at the 1994 tournament in Tulsa, Oklahoma. (Courtesy of USF Athletics.)

The Saints Hall of Fame began with the induction of six former CSF athletes in 1991. It has grown to include 67 former students and coaches whose time and achievements in the school's athletic programs have made a lasting impression. In the photograph above, former CSF head football coach Mike Slovik (left) congratulates 1996 inductee Mike Feminis ('90). Feminis was an All-American linebacker from 1986 to 1989 and was named NAIA Defensive Player of the Year by *USA Today* in 1989. He is also the only player in Saints football history to start all 41 games of his career. In the photograph below, Diana Fisher ('90) is congratulated at the 1996 ceremony by former women's basketball coach Karen McMillin (left). Fisher scored 1,121 points during her four-year career with the Saints. (Both courtesy of USF Athletics.)

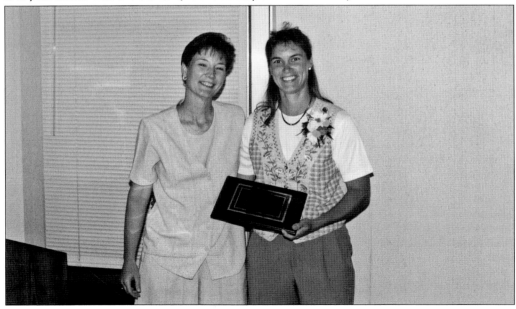

Rich Leunemann spent 18 seasons as head coach of the volleyball team at CSF. He guided the Saints to 14 CCAC titles and seven national tournaments, amassing a 590-262 record (.692) overall. He also served as the assistant athletic director from 1984 until 1999 when he left CSF to become head coach at Washington University in St. Louis, Missouri. (Courtesy of USF Athletics.)

Ann Deen ('91) had a career in Saints volleyball history that is yet to be matched. She was named player of the year 11 times, and she secured 2,433 career kills, the most amongst NAIA players and third-best career showing at all collegiate levels. Her skill and hard work earned her a tryout with the Olympic "B" team after her senior season. (Courtesy of USF Athletics.)

The Saints softball team has also had success throughout the years. For many years, they were a mainstay in the top-20 rankings, led for a time by the outstanding career of catcher Marissa Franzen ('95), pictured here. Ali Franzen, Marissa's younger sister, was a star pitcher from 1994 to 1997 and later became a successful head coach of the Saints' program. (Courtesy of USF Athletics.)

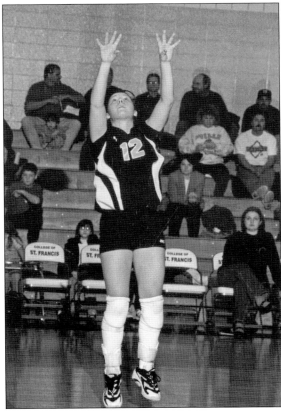

The Saints' athletic programs enthusiastically made the transition from college to university status in 1998. A small group of student-athletes can claim to have played for the school under both its names. Setter Deanne Hnatio ('00) was a third-team All-American volleyball player for the Saints, concluding her career in 1999 after playing as both a CSF Saint and a USF Saint. (Courtesy of USF Athletics.)

The Harold and Margaret Moser Performing Arts Center was made possible through funds from the capital campaign and through the leadership support of Harold and Margaret Moser, as well as many other alumni and friends. Dedicated in September 1993, the MPAC was a culmination of the dreams for an auditorium that began with the building era of the 1960s.

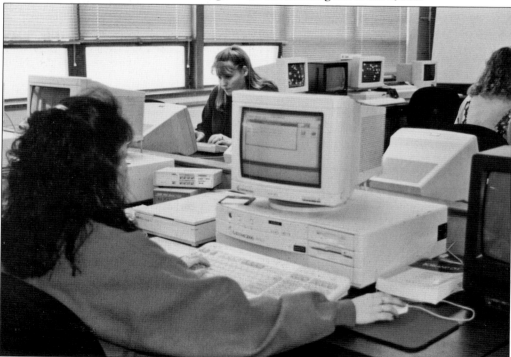

CSF was aware of the dramatic changes in technology during the 1990s, and it responded accordingly, creating the first computer lab on campus. As well as supplying students with new equipment, CSF also began expanding its academics to the Internet. The first online classes were offered in 1997, and this type of class has continued to grow in number and quality.

The rapid and dramatic changes in technology led to changing and expanding several academic programs at CSF. New programs were added, while old ones were updated. Mass communications students create and produce a weekly magazine-style video production called *Exploring Joliet*. This photograph shows the stage area and production room where students work on the show supervised by Prof. Richard Lorenc (far right).

The college's strength in the sciences has been centered in St. Albert Hall since it was built in 1959. A greenhouse was added to the south end of the building to provide more space for the study of biology and environmental science. In this *c.* 1996 photograph, Prof. William Bromer leads a discussion with students in the greenhouse.

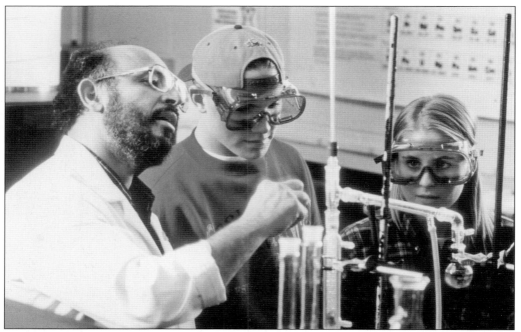

Continuing the tradition of excellence in the sciences set by Sister M. Vincent Kirk and the other sisters on the CSF faculty, Dr. Salim Diab (left) and the current faculty in the natural science department have continued to move forward, creating a learning environment that is fun, creative, and collaborative. Students' studies include collecting, analyzing, and synthesizing data; classes and internships at nationally acclaimed research facilities; and even cadaver dissection.

As a part of the health and safety promotions at USF, students participate in activities during Alcohol Awareness Week. Here, around 2002, director of health services Laurie Zack runs the equipment used to display a video-game driving course. A student tries to navigate the course while wearing goggles that simulate different levels of alcohol impairment.

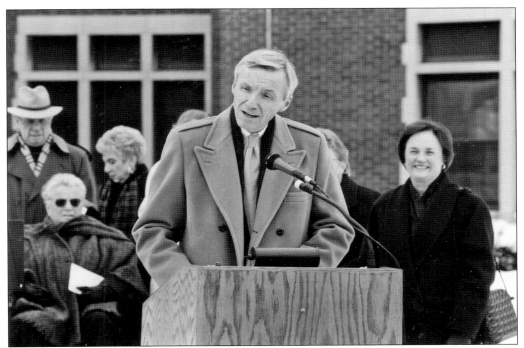

Dr. James Doppke became the seventh president of CSF in 1995, and he quickly began to make his mark on the school. In 1997, with the support of the board of trustees, the College of St. Francis gained university status. On January 1, 1998, the school officially became the University of St. Francis, and on January 16 a celebration was held with President Doppke addressing the campus in front of Tower Hall and trumpeters heralding the changing of the sign on the lawn. President Doppke said, "We are approaching a new century with a new name and a new logo and a new status as a university." (Both courtesy of photographer Ron Molk.)

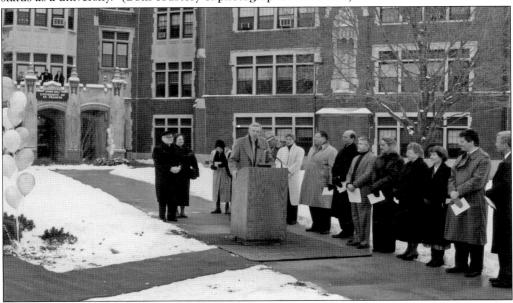

With the status of university, the school began to evaluate the changes that would be necessary to serve students more fully and effectively. Both St. Albert Hall and parts of Tower Hall were remodeled in the 1980s, so the school looked to Marian Hall and the Motherhouse. Renovation projects began for both buildings in 2005, with Marian's completed in a year and parts of the Motherhouse project ongoing.

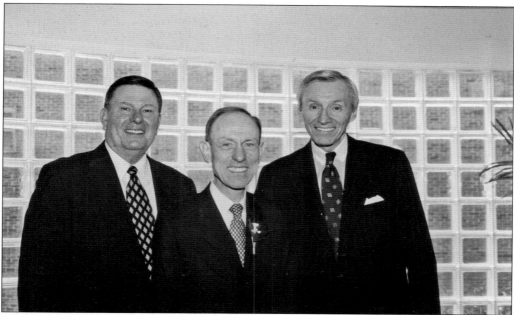

These three men have led the university for the past 35 years. From left to right are Dr. John C. Orr, Dr. Michael Vinciguerra, and Dr. James A. Doppke, seen here at an inauguration reception for Dr. Vinciguerra held on January 26, 2002. Their achievements include building the recreation center and the Moser Performing Arts Center; adding master's programs and the adult degree completion program; renovating the major buildings on campus; and achieving university status.

On September 11, 2002, area religious leaders, along with the University of St. Francis, invited the community to participate in an ecumenical prayer service and commemoration of the tragic events of September 11, 2001. The ceremony began at St. Raymond's Cathedral with the ringing of the bells. Participants walked from the cathedral to Tower Hall carrying symbolic lights. (Courtesy of photographer Ron Molk.)

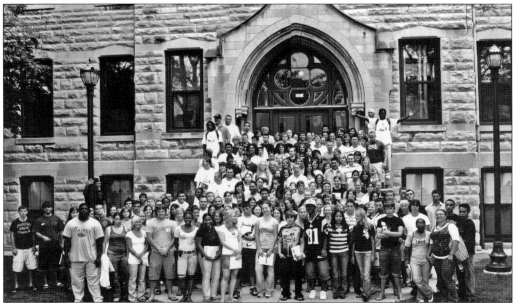

In 2004, the university purchased the Motherhouse and the campus land from the Sisters of St. Francis. It immediately began to renovate the building to create space for the Nursing College, administrative offices, and residents. The class of 2011 (pictured) posed on the steps of the Motherhouse during freshmen orientation, following the long tradition of commemorating groups and events on the steps of the oldest building on campus.

BIBLIOGRAPHY

Belden, David A. *Joliet*. Charleston, SC: Arcadia Publishing, 2008.

http://library.stfrancis.edu/archive.html

Magosky, P. Seth. *Historic Impressions: The History and Architecture of Joliet Homes*. Victoria, BC, Canada: Trafford, 2005.

Schackmuth, Kurt, and Carol Wassberg. *Lewis University*. Charleston, SC: Arcadia Publishing, 2002.

Sterling, Robert E. *Joliet: A Pictorial History*. St. Louis: G. Bradley Publishers, 1986.

Sterling, Robert E. *Joliet: Then and Now*. St. Louis: G. Bradley Publishers, 2004.

Voelker, Sister Marian. " '520' Centenary Resume." *Criteria*, 4(3), 1–30, Spring 1981.

www.provena.org/stjoes/body.cfm?id=750

www.stfrancis.edu/content/livinghistory/lh/csf.htm

INDEX

www.arcadiapublishing.com

Discover books about the town where you grew up, the cities where your friends and families live, the town where your parents met, or even that retirement spot you've been dreaming about. Our Web site provides history lovers with exclusive deals, advanced notification about new titles, e-mail alerts of author events, and much more.

MADE IN THE USA

Arcadia Publishing, the leading local history publisher in the United States, is committed to making history accessible and meaningful through publishing books that celebrate and preserve the heritage of America's people and places. Consistent with our mission to preserve history on a local level, this book was printed in South Carolina on American-made paper and manufactured entirely in the United States.

This book carries the accredited Forest Stewardship Council (FSC) label and is printed on 100 percent FSC-certified paper. Products carrying the FSC label are independently certified to assure consumers that they come from forests that are managed to meet the social, economic, and ecological needs of present and future generations.

FSC
Mixed Sources
Product group from well-managed
forests and other controlled sources

Cert no. SW-COC-001530
www.fsc.org
© 1996 Forest Stewardship Council

Find *Your* Place in History.